WO STAND DIE MAUER?
WHERE STOOD THE WALL?

Dieses Buch ist meinem Sohn Mario sowie meiner lieben
Mutter Frau Margarita Hampel geb. Hübner gewidmet,
die am 3. Dezember 2011 verstarb und der ich alles verdanke.

This book is dedicated to my son Mario, and my dear mother
Mrs. Margarita Hampel born Hübner,
who died on 3 December 2011 and to whom I owe everything.

Harry Hampel

# WO STAND DIE MAUER?
# WHERE STOOD THE WALL?

Stadtwandel Verlag

# DAS GETEILTE BERLIN
## BERLIN – THE DIVIDED CITY

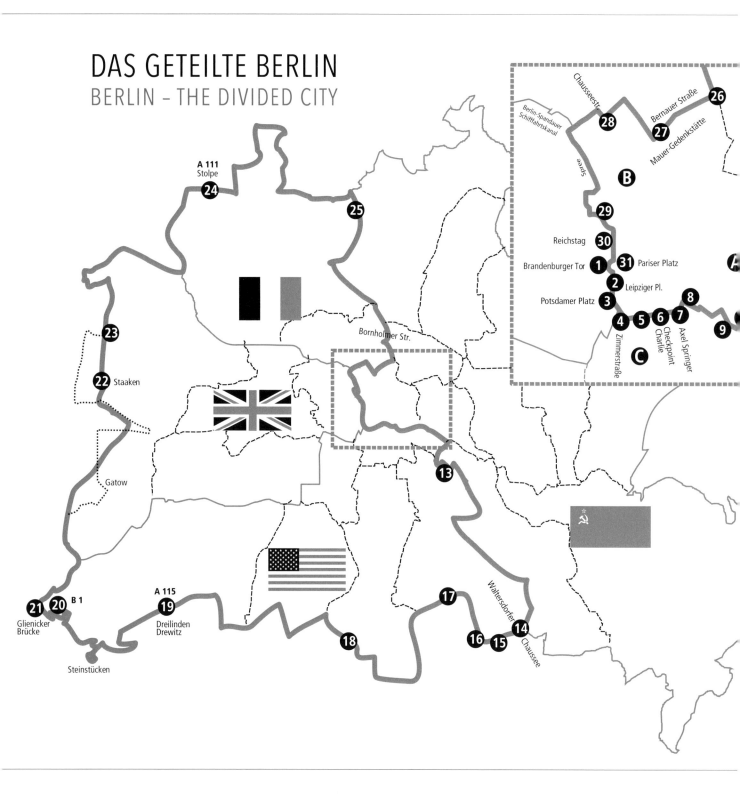

**A 111**
Stolpe
**24**

**25**

**23**

**22** Staaken

Gatow

**A 111**

Bornholmer Str.

Berlin-Spandauer Schifffahrtskanal

Chausseestr.

Bernauer Straße

**28**

**27**

**26**

Mauer-Gedenkstätte

**B**

Spree

**29**

Reichstag **30**

Brandenburger Tor **1** **31** Pariser Platz

**2** Leipziger Pl.

Potsdamer Platz **3**

**4** **5** **6** **7** **8**

Zimmerstraße

Checkpoint Charlie

Axel Springer

**9**

**C**

**A**

**13**

**17**

Waltersdorfer Chaussee

**14**

**16** **15**

**18**

**A 115**
**19**
Dreilinden
Drewitz

**21** **20** **B 1**

Glienicker Brücke

Steinstücken

**Ⓐ** 10 mittelalterliche Stadtmauer / medieval town wall, Waisenstr./Littenstr.

**Ⓑ** 12 Zoll- und Akzisemauer, 18./19. Jh. / customs and excise wall, 18th/19th century, Hannoversche Str. 9

**Ⓒ** 13 rekonstruierte Zoll- und Akzisemauer / reconstructed customs and excise wall, vor/in front of Stresemannstr. 66

**❶** 32/33, 34/35, 36/37, 138/139, 140/141 Brandenburger Tor / Brandenburg Gate

**❷** 38/39 Ebertstr./Behrenstr.

**❸** 40/41, 42/43, 44/45, 46/47, 48/49 Potsdamer Platz/Leipziger Platz

**❹** 50/51, 52/53 Stresemannstr./Niederkirchnerstr.

**❺** 54/55, 56/57, 58/59 Zimmerstr./Wilhelmstr.

**❻** 60/61, 62/63, 64/65, 66/67, 68/69 Checkpoint Charlie/Friedrichstr.

**❼** 70/71, 72/73, 74/75 Zimmerstr., Axel Springer

**❽** 76/77, 78/79 Zimmerstr./Axel-Springer-Str./Kommandantenstr.

**❾** 80/81 Heinrich-Heine-Str.

**❿** 82/83, 84/85 Dresdner Str./Waldemarstr.

**⓫** 86/87, 88/89 Bethaniendamm/Mariannenplatz

**⓬** 90/91 May-Ayim-Ufer/Oberbaumbrücke

**⓭** 92/93, 94/95 Heidelberger Str./Treptower Str.

**⓮** 96/97 Waltersdorfer Chaussee

**⓯** 98/99 Waßmannsdorfer Chaussee/Rudower Str.

**⓰** 100/101 Dörferblick

**⓱** 102/103 Ringslebenstr./Am Buschfeld

**⓲** 104/105 Marrienfelde/Großbeeren

**⓳** 106/107, 108/109 Autobahn 115 Dreilinden/Drewitz

**⓴** 110/111 Königstr./Klein Glienicke

**㉑** 112/113 Glienicker Brücke

**㉒** 114/115 Nennhauser Damm

**㉓** 116/117 Falkenseer Chaussee/Spandauer Str.

**㉔** 118/119 Autobahn 111 Stolpe

**㉕** 120/121 Blankenfelder Chaussee/Bahnhofstr.

**㉖** 122/123 Bernauer Str./Eberswalder Str./Schwedter Str.

**㉗** 124/125, 126/127 Bernauer Str., Mauer-Gedenkstätte / Wall Memorial

**㉘** 128/129 Liesenstr./Chausseestr.

**㉙** 130/131 Spreebogen ggü. / opposite Hugo-Preuß-Brücke

**㉚** 132/133, 134/135, 136/137 Reichstag, Ebertstr./Dorotheenstr.

**㉛** 142/143 Pariser Platz

# WO STAND DIE MAUER?

## WO KANN MAN NOCH ETWAS VON IHR SEHEN?

Fragen über Fragen, die so oder so ähnlich immer wieder von Berlin-Besuchern gestellt werden, ob an den Concierge im Hotel, den Busfahrer, den Stadtführer oder den Berliner Taxifahrer. Doch selbst Berliner, die zu Zeiten der Mauer in der einst geteilten Stadt gelebt haben, kommen ins Grübeln wenn sie diese Fragen beantworten sollen.

Besonders an solchen Stellen, wo große Veränderungen stattgefunden haben, wie zum Beispiel im Bereich des Potsdamer und Leipziger Platzes, der Ebert- oder der Zimmerstraße, kann man den Verlauf der Mauer kaum noch nachvollziehen. Um dem Vergessen entgegenzuwirken, und für alle, die zwar alt genug sind, die Stadt aber zu Mauerzeiten nie besucht haben und für so manchen Berliner, der sich nur noch vage an den Mauerverlauf erinnert, habe ich dieses Buch gemacht. Vor allem für die junge Generation, die keine eigene Erinnerung an die Mauer haben kann, soll diese Dokumentation anschaulich machen, wie die deutsche Hauptstadt sich seit dem Mauerfall verändert hat.

Als wäre es gestern gewesen, kann ich mich daran erinnern, wann ich die Idee für diese Fotoserie hatte. Ich stand eines schönen Herbsttages vor dem Brandenburger Tor und machte dort im Auftrag einer Berliner Tageszeitung Fotos für einen Artikel, der zum fünften Jahrestag des Mauerfalls erscheinen sollte. Nicht weit von meinem Standpunkt entfernt ging eine Berliner Familie vorbei, die wohl ihre Besucher durch die Stadt führte.

Sie blieben stehen, und da sie sich recht laut unterhielten, konnte ich hören, wie die Berliner von ihren Gästen gefragt wurden, wo denn vor dem Tor einst die Mauer verlief, worauf die Berliner keine rechte Antwort wussten. Sie standen da und fingen an, mit den Armen zu fuchteln und zu schwadronieren. Die einen sagten, die Mauer verlief mehr hier, während die anderen meinten, sie verlief mehr da oder doch mehr dort.

Ich stand da und konnte es kaum glauben, dass die Berliner fünf Jahre nach Mauerfall schon nicht mehr sagen konnten, wo vor dem Brandenburger Tor die Mauer verlief. Das war ja nun nicht irgendeine Stelle irgendwo im Stadtgebiet. Diese Art der Antworten hätte ich vielleicht verstehen können, wenn die Berliner mit ihrem Besuch irgendwo am Stadtrand gestanden hätten, wo man, wenn man dort nicht gewohnt hat, als Ortsunkundiger wohl kaum hätte sagen können, wo die Mauer genau verlaufen ist. Doch die Einheimischen standen vor einem weltbekannten Wahrzeichen der deutschen Hauptstadt und wurden sich nicht einig über die Frage ihrer Gäste: »Wo stand die Mauer?«

Genau da kam mir die Idee. Ich sagte mir, du musst was gegen das Vergessen tun. Du hast tausende von Mauerfotos in deinem Archiv. Nimm Aufnahmen mit historischem Bezug oder auch einfach atmosphärische Bilder, wiederhole die Aufnahmen vom selben Standpunkt in der selben Richtung mit der selben Optik und stelle die Fotos einander gegenüber.

# WHERE STOOD THE WALL?

## WHERE CAN WE STILL SEE SOME REMAINS OF IT?

Lots of questions like this are asked by visitors to Berlin again and again, whether the concierge at the hotel, the bus driver, the city guide or the Berlin taxi driver. But even Berliners who lived in the days of the Berlin Wall in the once divided city, start to wonder if they are to answer these questions.

Particularly in such places where great changes have taken place, such as in the area of Potsdamer Platz and Leipziger Platz, Ebertstraße or Zimmerstraße, the course of the Wall can hardly be retraced.

To counteract oblivion, and for those who have never visited the city during the Wall era despite being old enough, and for the many Berliners who only vaguely remember the course of the Wall, I made this book. Especially for the young generation who cannot have its own recollection of the wall, this documentation should make clear how the German capital has changed since the fall of the Wall.

As if it were yesterday, I can remember when I had the idea for this series of photographs. I stood on a beautiful autumn day in front of the Brandenburg Gate, taking photos on behalf of a Berlin daily newspaper for an article that was to appear on the fifth anniversary of the fall of the Wall. Not far from my standpoint, a Berlin family walked by, apparently taking their visitors through the city.

They stopped, and as they were talking quite loudly, I could hear the Berliners being asked by their guests about where the Wall once ran in front of gate, whereupon the Berliners knew no right answer.

They stood before the gate and began to wave their arms and jabber. Some said the wall ran more here, while the others thought it ran more there or rather over there.

I stood there and could hardly believe that the Berliners just five after fall of the Wall could not say where the Wall ran in front of the Brandenburg Gate. For this is not some place somewhere in the city. This kind of answers I might be able to understand if the Berliners had stood with their visitors somewhere on the outskirts, where, if you had not lived there, hardly could tell where the Wall exactly ran. But the locals were standing in front of a world-famous symbol of the German capital and could not agree on the question of their guests: "Where stood the Wall?"

Exactly then I got the idea. I said to myself, you have to do something against oblivion. You have thousands of Wall pictures in your archive. Take photographs with historical reference, or simply atmospheric images, repeat the shots from the same position in the same direction with the same lenses and put the photos side by side.

Thought, and in the next few weeks also done, these photos were the illustration of a large eight-page article commemorating the fifth anniversary of the fall of the Wall, which appeared in one of Berlin's major daily newspapers.

The very day after the article appeared, the owner of a long-established Berlin publishing house con-

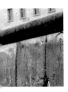

Gedacht und in den nächsten Wochen auch getan, waren diese Fotos die Bebilderung eines großen achtseitigen Artikels zum fünften Jahrestages des Mauerfalls, der in einer der großen Berliner Tageszeitungen erschien. Schon am Tag nach Erscheinen des Artikels meldete sich Inhaber eines alteingesessenen Berliner Verlages, der ganz begeistert war von der Idee der Fotoserie, und schon kurze Zeit später erschienen die Fotos in Buchform.

Nie habe ich mir träumen lassen, dass ich meine Mauerfotos, die ja im Rahmen meiner Tätigkeit als Pressefotograf entstanden sind, eines Tages in einer solchen Dokumentation verwenden kann.

Vielleicht wird dem einen oder anderen Berlin-Kenner die eine oder andere Maueransicht fehlen, doch dieses Buch erhebt nicht den Anspruch auf Vollständigkeit. Ich habe noch ein paar Tausend Mauerbilder im Archiv. Ein damit bebildertes Buch wäre kaum zu produzieren. Es wäre wohl auch kaum zu tragen und kaum bezahlbar. So bleibt es bei der von mir getroffenen Auswahl von Aufnahmen, die zum Teil Unikate sind, wie zum Beispiel das Ausschwenken der Kontrollbaracke am Checkpoint Charlie, fotografiert im Juni 1990, oder der Blick vom Dach des Brandenburger Tores nach Norden, Süden und Westen, die ich im Februar 1990 gemacht habe. An vielen Stellen habe ich über die Jahre auch Zeitreihen mit mehr als zwei Bildern aufgenommen.

Die Fotos im Buch haben durchaus einen gewissen Aha-Effekt. Sie zeigen, vom Brandenburger Tor ausgehend und am Reichstag endend, im Uhrzeigersinn um West-Berlin Grenzabschnitte in den Stadtteilen bzw. Vororten Tiergarten/Mitte, Kreuzberg/Mitte, Kreuzberg/Friedrichshain, Neukölln/Treptow, Rudow/Schönefeld, Zehlendorf/Kleinmachnow, Wannsee/Potsdam, Staaken/Staaken (auch Staaken am westlichen Stadtrand war geteilt!), Spandau/Falkensee, Heiligensee/Stolpe, Lübars/Blankenfelde (Stadtbezirk Pankow), Wedding/Prenzlauer Berg und Wedding/Mitte.

So, glaube ich, sind recht abwechslungsreiche Blicke auf den einstigen Verlauf der Mauer zu sehen, der dem interessierten Betrachter zeigt, wo sie stand, die Mauer, die nach der Chinesischen Mauer wohl bekannteste Mauer der Welt. Wir sollten nie vergessen, dass an dieser Mauer, an dieser unmenschlichen Grenze auf Menschen geschossen wurde, dort Menschen ihr Leben verloren, wenn sie ohne Genehmigung ihr Land verlassen wollten nur um die Möglichkeiten zu haben, frei Reisen zu können, frei Reden zu dürfen und frei über ihr Leben zu bestimmen.

Ein Buch gegen das Vergessen.

tacted me, being really excited about the idea of the photo series, and a short time later, the photos were published as a book. I never dreamed that one day I could use my Wall photos in such a documentary, which I photographed indeed during my work as a press photographer.

Perhaps one or another Berlin connoisseur will miss one or another view of the Wall, but this book does not claim to be complete. I still have a few thousand Wall pictures in my archive. A book illustrated with all of them would be hard to produce. It would probably also be hard to carry around and extremely expensive. So it remains with my selection of shots some of which are unique, such as the removal of the control shack at Checkpoint Charlie photographed in June 1990, or the view from the roof of the Brandenburg Gate to the north, south and west, I took in February 1990. In many places I have also taken time series with more than two images over the years.

The photos in the book have quite a wow factor. They show border sections clockwise around West Berlin, starting from the Brandenburg Gate and ending at the Reichstag, in the neighbourhoods or suburbs of Tiergarten/Mitte, Kreuzberg/Mitte, Kreuzberg/Friedrichshain, Neukölln/Treptow, Rudow/Schönefeld, Zehlendorf/Kleinmachnow, Wannsee/Potsdam, Staaken/Staaken (Staaken on the west-ern outskirts was divided, too!), Spandau/Falkensee, Heiligensee/Stolpe, Lübars/Blankenfelde (district of Pankow), Wedding/Prenzlauer Berg and Wedding/Mitte.

So, I think, there are quite varied views of the former course of the wall to see, showing the interested beholder where it stood, the Wall, the most famous wall in the world after the Great Wall of China.

We should never forget, that at this wall, at this inhuman border, people were shot at, that people lost their lives there, if they wanted to leave their country without permission just to have the of freedom to travel freely, to be allowed to talk freely and to choose their own lives freely.

A book against oblivion.

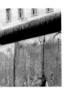

# GESCHICHTE DER MAUERN UM UND IN BERLIN

## 1. STADTMAUER DES MITTELALTERS UND BERLINER FESTUNG

Ab ihrer Entstehung im 12. und 13. Jahrhundert schützten sich die Städte Berlin und Cölln zunächst durch Wälle, Palisadenzäune und Gräben vor äußeren Feinden. Ab etwa um 1250 kam eine befestigte, aus Feldsteinen bestehende, bis zu zwei Meter hohe Stadtmauer hinzu. Entlang der Grenze zwischen beiden Städten, der Spree, gab es keine Mauer. Anfangs hatte Berlin drei und Cölln zwei Stadttore. Wo die Stadtmauer auf die Spree stieß, wurden Ober- und Unterbaum errichtet, Sperren aus eingerammten Eichenpfählen mit einem schmalen Durchlass, der nachts mit einem Schwimmbalken (»Baum«) gesperrt wurde. Wo ursprünglich eine Furt durch die Spree war, wurde bald nach der Stadtgründung der Mühlendamm zwischen Berlin und Cölln errichtet, der den Fluss zur Energiegewinnung staute und für Schiffe unpassierbar war. Das erleichterte die Durchsetzung von Beschränkungen und Abgaben im Warenverkehr. Auch der Spreekanal, der den Mühlendamm südlich umgeht, wurde erst um 1550 nach dem Bau eine Schleuse durchgehend befahrbar.

Im 13. Jahrhundert wurde die Stadtmauer mit Ziegeln ausgebessert und auf bis zu fünf Meter erhöht. Zur Verteidigung dienten in unregelmäßigen Abständen eingebaute Schießscharten, Türme und Wiekhäuser, das waren nach innen offene Türme, die später oft zu Wohnhäusern ausgebaut wurden. Im 15. Jahrhundert wurden zwei etwa 15 Meter breite

Gräben um die Stadtmauer gezogen und zwischen ihnen ein bis zu zehn Meter breiter Erdwall aufgeschüttet.

Die Stadtmauer verfiel mit der Zeit und wurde nach 1650 durch eine neue Festungsanlage mit mehreren Bastionen ersetzt, die ein erweitertes Stadtgebiet umfasste und ab 1734 geschleift wurde.

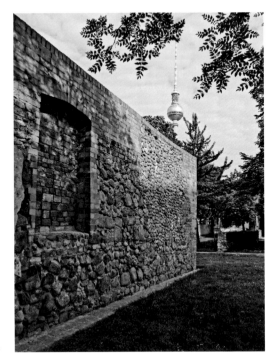

# HISTORY OF THE WALLS AROUND AND IN BERLIN

## 1 TOWN WALL IN THE MIDDLE AGES AND FORTIFICATION OF BERLIN

From their creation in the 12th and 13th centuries, the towns of Berlin and Cölln protected themselves against outside enemies at first by walls, picket fences and ditches. From about 1250 a fortified town wall of cobblestones was added, up to two metres high. Along the border between the two towns, the river Spree, there was no wall. Initially, Berlin had three and Cölln two town gates. Where the walls met the river Spree, the upper and lower boom were erected, barriers of oak piles rammed into the river-bed with a narrow passageway locked at night with a floating tree trunk ("boom"). Where there was originally a ford through the river Spree, the mill dam between Berlin and Cölln was built soon after the towns were founded, which dammed the river for power and was impassable for ships. This facilitated the enforcement of restrictions and charges on goods. Also the Spree Canal, bypassing the mill dam to the south, became navigable all through only around 1550 after a lock was built.

In the 13th century the town wall was repaired and increased to up to five metres using bricks. As defenses there were, at irregular intervals, loopholes, towers and "Wiekhäuser" (lookout houses), that were towers open to the inside, later often reconstructed into residences.

In the 15th century, two 15-metre-wide ditches were cut around the town wall and an up to ten metres wide rampart was banked up between them. The town wall dilapidated with time and was replaced after 1650 by new fortifications with several bastions, which surrounded an extended urban area and were slighted from 1734 on.

*Mittelalterliche Stadtmauer*
*des 13. Jahrhundert von der Littenstraße aus, also von außen. Später wurden Teile der Stadtmauer mit Häusern überbaut, wodurch, wie hier, Mauerstücke erhalten blieben.*

*Medieval town wall*
*of the 13th century, seen from Littenstraße, thus from the outside. Parts of the town wall were later built over with houses, what, as here, preserved some wall sections.*

## 2. ZOLL- UND AKZISEMAUER DES 18. UND 19. JAHRHUNDERTS

Ab 1734 bis 1737 wurde unter König Friedrich Wilhelm I. von Preußen (Soldatenkönig genannt) eine Zoll- und Akzisemauer gebaut. Sie sollte sicherstellen, dass Zölle und die Akzise, eine Verbrauchssteuer auf Güter des täglichen Bedarfs, bezahlt wurden, aber auch Desertionen von Soldaten verhindern.

Sie bezog die bereits 1705 errichtete sogenannte Linie ein, ein Palisadenzaun nördlich der Stadt entlang der späteren Linienstraße in Berlin-Mitte. Ebenso erinnert die Palisadenstraße in Friedrichshain an den damaligen Verlauf. Die Zollmauer bestand überwiegend aus Holzpalisaden und war nur zum Teil gemauert. Sie wurde mit 14 Stadttoren mit Torhäusern für Zoll und Militär versehen. Oberbaum und Unterbaum wurden entsprechend dem neuen Mauerverlauf stadtauswärts verlegt.

Die Akzisemauer umfasste anfangs nicht nur Berlin und seine Vorstädte, sondern vor allem im Osten und Süden auch noch viel unbebautes, meist landwirtschaftlich genutztes Land.

Zwischen 1786 und 1802 wurden die hölzernen Palisaden durch eine Steinmauer ersetzt, die Akzisemauer insgesamt verstärkt und auf etwa vier Meter erhöht.

Da Berlin weiter wuchs, wurden in der ersten

**Zoll- und Akzisemauer**
*Einziges oberirdisch erhaltenes Stück der Mauer des 18. und 19. Jahrhunderts. Dieses Mauerstück, Hannoversche Straße 9, wurde um 1835 im Zusammenhang mit dem Neuen Tor nach Entwurf von Karl Friedrich Schinkel gebaut.*

**Customs and Excise wall**
*The only part of the 18th and 19th century wall being preserved aboveground. This wall section at Hannoversche Straße 9 was built around 1835 in connection with the New Gate, after a design by Karl Friedrich Schinkel.*

# 2 CUSTOMS AND EXCISE WALL OF THE 18TH AND 19TH CENTURIES

From 1734 to 1737, under King Frederick William I of Prussia (called Soldier King), a customs and excise wall was built. It should ensure that customs and the excise, a duty on goods for personal consumption, were paid, but should also prevent desertions of soldiers. It included the so-called line already built in 1705, a picket fence north of the city along the later Linienstraße in Berlin-Mitte. Similarly, the Palisadenstraße in Friedrichshain recalls to the former course. The customs wall consisted mainly of wooden palisades, and was only partially bricked. It was equipped with 14 gates with gate lodges for customs and military. Upper boom and lower boom were moved outward according to the new course of the wall.

The excise wall initially comprised not only Berlin and its suburbs, but especially in the east and south still much undeveloped, mostly agricultural land.

Between 1786 and 1802, the wooden palisades were replaced by a stone wall, the whole excise wall reinforced and increased to about four metres.

As Berlin grew, multiple sections of the excise wall and customs gates were rebuilt further out of town in the first half of the 19th century. Some

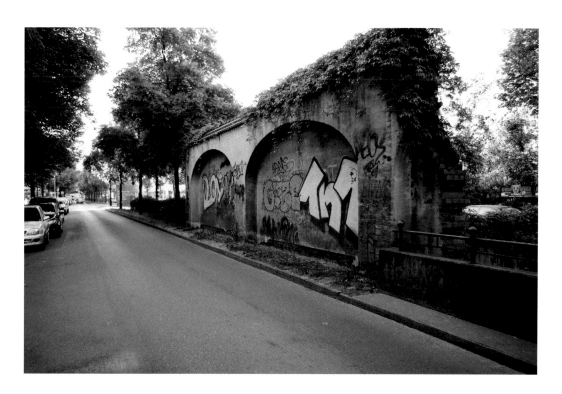

*Rekonstruiertes Stück Zoll- und Akzisemauer*
*auf der Stresemannstraße zum 750jährigen Stadtjubiläum 1987, anschließend an ein »archäologisches Fenster« mit originalen Fundamentresten nebst einer alten Wasserleitung.*

**Reconstructed section of the Customs and Excise Wall**
*on Stresemannstraße for the city's 750th anniversary in 1987, adjacent to an "archaeological window" with remains of original wall foundation and an old water conduit.*

Hälfte des 19. Jahrhunderts mehrfach Abschnitte der Akzisemauer und Zolltore weiter stadtauswärts neu errichtet. Einige Stadttore erhielten repräsentative Neubauten, wie das Brandenburger Tor 1789/90. Vier weitere Stadttore wurden gebaut, das Neue Tor (1832), das Anhalter Tor (1839/40), das Köpenicker Tor am Lausitzer Platz (1842) und das Wassertor (1848).

Vor einigen Toren entstanden noch heute existierende Friedhöfe, wie der Dorotheenstädtische Friedhof an der Chausseestraße, der Friedhof der St.-Georg-Gemeinde an der Straße Prenzlauer Berg, mehrere Friedhöfe an der Friedenstraße sowie die Friedhöfe vor dem Halleschen Tor.

Ebenso Kopfbahnhöfe der im 19. Jahrhundert entstehenden Eisenbahnstrecken, der Potsdamer Bahnhof (1838), der Anhalter Bahnhof (1841), der Stettiner Bahnhof (1842, beim heutigen S-Bahnhof Nordbahnhof); der Hamburger Bahnhof (1846) lag innerhalb der Akzisemauer. Zwischen diesen Kopfbahnhöfen wurde 1851 für den Güter- und Militärverkehr die Verbindungsbahn meist entlang der Akzisemauer gebaut. Auch die erste Berliner U-Bahn-Strecke wur-

de zwischen 1896 und 1902 entlang dem Verlauf der inzwischen abgerissenen Akzisemauer im heutigen Kreuzberg gebaut.

Vor allem ab der Mitte des 19. Jahrhunderts entstanden außerhalb der Akzisemauer neue Vorstädte, das Berliner Stadtgebiet umfasste schon 1840 mehr als das Doppelte des von der Mauer umgebenen Gebietes. Als Folge davon wurden an den Zufahrtsstraßen zu Berlin teils weit vor den Toren der Stadt sogenannte Akzise- oder Steuerhäuser errichtet, in denen nun die Abgaben bezahlt werden mussten. Das einzige noch erhaltene Akzisehaus liegt etwa einen halben Kilometer vor dem Schlesischen Tor auf der Lohmühleninsel im Landwehrkanal.

Ihrer hauptsächlichen Funktion enthoben, wurde die Akzisemauer 1860 per Dekret aufgehoben. Am 1. Januar 1861 wuchs das Stadtgebiet durch Eingemeindungen noch einmal um knapp 70 Prozent, weit über die Akzisemauer hinaus.

Zwischen 1867 und 1870 wurde die Akzisemauer und mit ihr fast alle Tore abgerissen, nur das repräsentative Brandenburger Tor von 1790 blieb erhalten.

town gates got representative new buildings, such as the Brandenburg Gate in 1789/90. Four more town gates were built, the New Gate (1832), the Anhalt Gate (1839/40), the Köpenick Gate at Lausitzer Platz (1842) and the Water Gate (1848).

Outside some gates cemeteries still existing today were laid out, such as the Dorotheenstadt cemetery on Chausseestraße, the cemetery of St. George's parish on the street Prenzlauer Berg, several cemeteries on Friedenstraße and the cemeteries outside the Halle Gate.

Likewise, terminus stations of the railway lines built in the 19th century, Potsdam Station (1838), Anhalt Station (1841), Stettin Station (1842, at today's S-Bahn station North Station); Hamburg Station (1846) was within the excise wall. Between these terminus stations, the junction line for freight and military traffic was built in 1851 mostly along the excise wall. Also, the first Berlin subway line was built between 1896 and 1902 along the course of the meanwhile demolished excise wall in today's Kreuzberg.

Especially since the middle of the 19th century new suburbs were developed outside the excise wall, in 1840, the city of Berlin comprised already more than twice the area surrounded by the wall. As a result, so-called excise or tax houses were built on the access roads to Berlin, some of them far outside the gates, where the duties had to be paid now. The only remaining excise house is located about half a kilometre from the Silesian Gate on Lohmühleninsel in the Landwehr Canal.

Divested of its main function, the excise wall was lifted by decree in 1860.

On 1 January 1861, the city area once again grew by nearly 70 percent due to incorporations, well beyond the excise wall.

Between 1864 and 1870, the excise wall was demolished and almost all the gates with it, only the representative Brandenburg Gate from 1790 remained.

# 3. DDR-MAUER

## ENTSTEHUNG VON WEST-BERLIN

Nach den Vorschlägen der European Advisory Commission (EAC) der Alliierten UdSSR, USA und Großbritannien vom 12. September und 14. November 1944 in London beschlossen die Alliierten in der Konferenz von Jalta auf der Krim vom 4. bis 11. Februar 1945, Deutschland in vier Besatzungszonen und Berlin in vier Sektoren aufzuteilen. Jeder der drei Alliierten und Frankreich sollte je eine Besatzungszone verwalten und ein gemeinsamer Alliierter Kontrollrat sollte Deutschland regieren, während Berlin von einer gemeinsamen alliierten Kommandantur regiert werden sollte. Stalin hatte der Beteiligung Frankreichs nur zugestimmt, weil dessen Besatzungsgebiet aus Teilen der Besatzungsgebiete von USA und Großbritannien gebildet wurde, das sowjetische also nicht verkleinert wurde.

Die deutschen Gebiete östlich von Oder und Lausitzer Neiße wurden bereits von Polen bzw. der UdSSR verwaltet, seit sie von Herbst 1944 an von sowjetischen Truppen erobert und besetzt wurden und fast die gesamte deutsche Bevölkerung von dort evakuiert wurde, geflohen war oder vertrieben wurde.

Das Potsdamer Abkommen vom 2. August 1945 als Ergebnis der Potsdamer Konferenz übertrug Polen bzw. der UdSSR einstweilen die Verwaltung und legte fest, dass diese Gebiete nicht Teil der Sowjetischen Besatzungszone (SBZ) sind. Die endgültige Regelung sollte einem Friedensvertrag vorbehalten bleiben. Jeder Sektor in Berlin bestand aus mehreren Verwaltungsbezirken, die durch das »Gesetz über die Bildung einer neuen Stadtgemeinde Berlin (Groß-Berlin-Gesetz)« vom 27. April 1920 am 1. Oktober 1920 entstanden waren. Die Stadtgrenze, später Grenze West-Berlins zur SBZ, war im Süden des Verwaltungsbezirks Zehlendorf am 1. Januar 1928 durch Eingemeindung des Gutsbezirks Düppel noch einmal erweitert worden.

Die Grenzen der Verwaltungsbezirke sind diejenigen nach der Satzung vom 27. März 1938, die viele dieser Grenzen begradigt hat, darunter solche, die später die Grenze zwischen den West-Sektoren und dem Ost-Sektor bildeten (z. B. Mitte/Kreuzberg entlang der Niederkirchnerstraße, Pankow/Wedding entlang der Nordbahn, Treptow/Neukölln entlang des Teltowkanals).

In der Schlacht um Berlin besetzten sowjetische Truppen zwischen dem 21. April und dem 2. Mai 1945 ganz Berlin. Vom 1. bis 4. Juli 1945 trafen die US-amerikanischen und britischen sowie eine Vorausabteilung der französischen Besatzungstruppen in den ihnen zugewiesenen Sektoren ein, aus denen sich die sowjetischen Besatzungstruppen zuvor zurückgezogen hatten. Schon bald gab es sich verschärfende politische Konflikte zwischen den West-Alliierten und der Sowjetunion.

Am 20. Oktober 1946 fand die erste Wahl zur Stadtverordnetenversammlung von Groß-Berlin in allen vier Sektoren gemeinsam statt und endete mit einem deutlichen Sieg der SPD vor CDU und SED. Es folgten zunehmende Auseinandersetzungen in der Verwaltung und in der Stadtverordnetenversammlung. Unter anderem wegen Streit um die Währungsreform, der mit der Ausgabe der West-DM in West-Berlin am 24. Juni 1948 gipfelte, blockiert die sowjetische Besatzungsmacht von diesem Tag an bis zum 12. Mai 1949 Land- und Wasserverbindungen zwischen den Westzonen und West-Berlin.

Nur die im November 1945 vereinbarten drei Luftkorridore zwischen West-Berlin und Hamburg, Hannover sowie Frankfurt am Main blieben offen. Ab 26. Juni 1948 versorgten die West-Alliierten mit der Luftbrücke ihre Sektoren aus der Luft, während viele West-Berliner in Ost-Berlin und der SBZ weiter billig u.a. Grundnahrungsmittel kauften.

Mit der Blockade endete auch die gemeinsame Verwaltung Berlins. Am 6. September 1948 verlegte die von SPD und CDU dominierte Stadtverordnetenversammlung ihre Sitzungen nach West-Berlin. Am 30. November 1948 führte die SED-Frak-

# 3 THE GDR WALL

## EMERGENCE OF WEST BERLIN

According to the proposals of the European Advisory Commission (EAC) of the Allies USSR, USA and Great Britain of 12 September and 14 November 1944 in London, the Allies decided at the Yalta Conference in the Crimea from 4 to 11 February 1945 to divide Germany into four occupation zones and Berlin into four sectors. Each of the three Allies and France was to administer an occupation zone and a joint Allied Control Council should govern Germany, while Berlin should be governed by a joint Allied Kommandatura. Stalin had only agreed to the participation of France because its occupation area was formed from parts of the occupation areas of the USA and Great Britain, therefore not reducing the Soviet one.

The German territories east of the Oder and Lusatian Neisse were already being administered by Poland and the USSR respectively, since they had been conquered and occupied from autumn 1944 on by Soviet troops and almost the entire German population had been evacuated, had fled or had been expelled from there. The Potsdam Agreement of 2 August 1945 as result of the Potsdam Conference assigned the administration to Poland and the USSR for the time being and determined that these areas are not part of the Soviet occupation zone (SBZ). The final rule should be reserved to a peace treaty.

Each sector in Berlin consisted of several administrative districts created on 1 October 1920 by the "Law on the formation of a new municipality of Berlin (Greater Berlin Act)" of 27 April 1920. The city boundary, later border between West Berlin and the Soviet zone, was extended again on 1 January 1928 in the south of Zehlendorf district by incorporation of the estate district of Düppel. The boundaries of administrative districts are those set out in the by-law of 27 March 1938, which has straightened many district boundaries, some of those later became part of the border between the western sectors and the eastern sector (e.g. Mitte/Kreuzberg along Niederkirchnerstraße, Pankow/Wedding along the northern railway line, Treptow/Neukölln along the Teltow Canal).

In the Battle of Berlin, Soviet troops occupied between 21 April and 2 May 1945 the whole of Berlin. In July 1945, the American and British as well as an advance guard of the French occupation forces arrived in their assigned sectors, from which the Soviet occupation troops had withdrawn before. Soon there were worsening political conflicts between the Western Allies and the Soviet Union.

On 20 October 1946, the first elections to the City Council of Greater Berlin was held jointly in all four sectors and ended with a clear victory of the SPD ahead of CDU and SED. This was followed by increasing conflicts in the administration and the city council. Partly because of the dispute over the currency reform, which culminated with the issuance of the western German Mark in West Berlin on 24 June 1948, the Soviet occupying power blocked from that day until 12 May 1949 land and water connections between the western zones and West Berlin.

Only the three air corridors between West Berlin and Hamburg, Hanover, Frankfurt agreed in November 1945 remained open. As of 26 June 1948 the Western Allies supplied their sectors from the air with the airlift, while many West Berliners continued to buy, among others, cheap staple food in East Berlin and the Soviet zone.

With the blockade the joint administration of Berlin ended. On 6 September 1948, the city council dominated by SPD and CDU moved its meetings to West Berlin. On 30 November 1948, the SED group held with hundreds of alleged delegations of East Berlin companies a "town council meeting", which declared the magistrate deposed and elected Friedrich Ebert (eldest son of the former Reich President of the same name) as mayor. On 5 December

tion mit hunderten angeblicher Abordnungen der Ost-Berliner Betriebe eine »Stadtverordnetenversammlung« durch, die den Magistrat für abgesetzt erklärte und Friedrich Ebert (ältester Sohn des gleichnamigen ehemaligen Reichspräsidenten) zum Oberbürgermeister wählte. Am 5. Dezember 1948 sollte erneut eine gemeinsame Wahl zur Stadtverordnetenversammlung von Groß-Berlin stattfinden, die jedoch nur in West-Berlin durchgeführt werden konnte, weil die sowjetische Besatzungsmacht sie in ihrem Sektor verbot.

## ENTSTEHUNG DER DEUTSCHEN DEMOKRATISCHEN REPUBLIK (DDR)

Ab 23. Februar 1948 verhandelten die drei West-Alliierten und die Benelux-Staaten unter Ausschluss der UdSSR in der Londoner Sechsmächtekonferenz erstmals über einen separaten Staat in den drei Westzonen. Aus Protest dagegen verließ der Vertreter der UdSSR am 20. März 1948 den Alliierten Kontrollrat. In den drei Westzonen fand ab 20. Juni 1948 die Währungsreform mit Einführung der Deutschen Mark (DM) statt. Am 1. Juli 1948 übergaben die Militärgouverneure der drei West-Alliierten den westdeutschen Ministerpräsidenten die »Frankfurter Dokumente« mit Auftrag zur Bildung eines westdeutschen Staates. Ab 10. August 1948 erarbeiteten stimmberechtigte Vertreter der westdeutschen Länder und nicht stimmberechtigte Vertreter West-Berlins eine neue Verfassung, das Grundgesetz.

Ab 1. Januar 1947 bildeten die US-amerikanische und die Britische Zone das Vereinigte Wirtschaftsgebiet, die Bizone, mit der am 8. April 1949 die Französische Zone zur Trizone verbunden wurde, aus der am 24. Mai 1949 mit Inkrafttreten des Grundgesetzes die Bundesrepublik Deutschland entstand.

Ab 19. März 1948 bis zum 22. Oktober 1948 wurde im Osten nach einem Entwurf der SED von 1946 für Gesamt-Deutschland die Verfassung einer Deutschen Demokratischen Republik ausgearbeitet, welche am 19. März 1949 vom 1. Deutschen Volksrat angenommen wurde. Am 7. Oktober 1949 wird in der SBZ die Deutsche Demokratische Republik (DDR) gegründet, aus den deutschen Zentralverwaltungen in der SBZ werden Ministerien der DDR.

## SICHERUNG DER GRENZE

Am 10. März 1952 hat Stalin den drei West-Alliierten in einer diplomatischen Note Vorschläge zur Schaffung eines wiedervereinigten, neutralen Deutschlands gemacht. In dem nachfolgenden Notenaustausch wurde keine Einigung erzielt.

Am 26. und 27. Mai 1952 wurde in Westdeutschland nach massivem Druck der USA und gegen die Bedenken der anderen westeuropäischen Staaten der Vertrag über die Gründung der Europäischen Verteidigungsgemeinschaft EVG unterzeichnet, als Rechtsgrundlage für die bereits seit 1950 vorbereitete westdeutsche Wiederbewaffnung. Somit wurde die Spaltung Deutschlands, nachdem sie 1948 wirtschaftlich und 1949 politisch durchgesetzt wurde, nun auch militärisch vollzogen. Dies nahm die DDR zum Anlass, noch am 27. Mai an ihrer Grenze zur Bundesrepublik und der Außengrenze zu West-Berlin mit der Errichtung von Sperranlagen zu beginnen und Verkehrswege außerhalb der Grenzübergänge unpassierbar zu machen. Die Sektorengrenze zwischen Ost- und West-Berlin blieb offen.

Die wirtschaftliche Lage der DDR verschlechterte sich zunehmend, was zu vermehrter Abwanderung vor allem junger und gut ausgebildeter Menschen führte, eine »Abstimmung mit den Füßen«. Am 17. Juni 1953 kam es in Ost-Berlin nach Erhöhung von Arbeitsnormen zu Streiks und einem Aufstand, der auf die DDR übergriff. Er wurde mit Hilfe sowjetischer Besatzungstruppen niedergeschlagen.

In den Folgejahren verschärfte sich in der DDR die Krise wieder und die Abwanderung nahm erneut zu. Anders als 1952/1953 blieben Wirtschaftshilfen durch die UdSSR aus.

1958 wollte die UdSSR West-Berlin zu einer entmilitarisierten Freien Stadt machen, eine Anerkennung der DDR durch die Bundesrepublik und einen Friedensvertrag erreichen. Am 27. November 1958

1948 another joint election to the City Council of Greater Berlin was scheduled, but it could be held only in West Berlin, because the Soviet occupying power banned it in its sector.

## EMERGENCE OF THE GERMAN DEMOCRATIC REPUBLIC (GDR)

From 23 February 1948 on, the three Western Allies and the Benelux countries, excluding the USSR, negotiated in the London Six-Power Conference for the first time about a separate state in the three western zones. In protest against that, the representative of the USSR left the Allied Control Council on 20 March 1948.

In the three Western zones, the currency reform took place with the introduction of the German Mark from 20 June 1948 on. On 1 July 1948, the military governors of the three western allies handed to the West German State Premiers the "Frankfurt Documents" with the mandate to form a West German state. From 10 August 1948, voting representatives of the West German states and non-voting representatives of West Berlin drafted a new constitution, the Basic Law.

From 1 January 1947, the American and the British zones together formed the Combined Economic Area, Bizonia, to which the French zone was added on 8 April 1949, forming Trizonia, from which arose the Federal Republic of Germany, when the Basic Law came into force on 24 May 1949.

From 19 March 1948 to 22 October 1948, the constitution of a German Democratic Republic was worked out based on a draft by the SED from 1946 in the East for the whole of Germany, which was adopted by the first German People's Council on 19 March 1949. On 7 October 1949, the German Democratic Republic (GDR) was founded in the Soviet zone, the German Central Administrations in the SBZ became ministries of the GDR.

## SECURING THE BORDER

On 10 March 1952, Stalin sent proposals for the creation of a united, neutral Germany to the three Western Allies in a diplomatic note. In the subsequent exchange of notes no agreement was reached.

On 26 and 27 May 1952, the Treaty establishing the European Defence Community was signed in West Germany after massive U.S. pressure against the concerns of other Western European countries, as the legal basis for the West German rearmament prepared since 1950. Thus, the division of Germany was implemented also militarily, after it was enforced economically in 1948 and politically in 1949. The GDR took this as an opportunity to begin the construction of barriers at its border with the Federal Republic and the outer border to West Berlin on that very day and to make traffic routes impassable outside of border crossings. The sector boundary between East and West Berlin remained open.

The economic situation in the GDR deteriorated more and more, what caused increased emigration of mainly young and educated people, a "vote with feet". On 17 June 1953 East Berlin workers went on strike after an increase in production quotas, and an uprising started which spread to the GDR. It was put down with the help of Soviet occupation forces.

During the following years, the crisis in the GDR exacerbated and emigration rose again. Unlike 1952/1953, there was no economic aid by the USSR.

In 1958, the USSR wanted to make West Berlin a demilitarized free city, to achieve recognition of the GDR by the Federal Republic, and a peace treaty. On 27 November 1958, it announced to the Western Allies to transfer control of all routes between the Federal Republic and the Western sectors of Berlin to the GDR, if Berlin would not become a free city within half a year. The Western Allies rejected this as unacceptable.

There was another wave of refugees from the GDR in 1960, when during the "socialist spring" al-

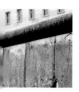

kündigte sie den West-Alliierten an, der DDR die Kontrolle aller Wege zwischen dem Bundesgebiet und den West-Sektoren Berlins zu übertragen, wenn Berlin nicht innerhalb eines halben Jahres zu einer Freien Stadt würde. Die West-Alliierten lehnten das als unannehmbar ab. Eine weitere Flüchtlingswelle aus der DDR gab es 1960, als im »Sozialistischen Frühling« fast alle verbliebenen Einzelbauern in die Landwirtschaftlichen Produktionsgenossenschaften (LPG) gezwungen wurden. Die Entscheidung zur Sicherung der Grenze um West-Berlin fiel letztlich bei einer Besprechung zwischen Chruschtschow und Ulbricht am 3. August 1961 in Moskau, nachdem die sowjetische Führung seit Mitte der 1950er Jahre die Grenzsicherung lange ablehnte, während die DDR-Führung zunehmend darauf drängte.

## MAUERBAU, IM GEHEIMEN VORBEREITET

»Niemand hat die Absicht eine Mauer zu errichten«. Dieser letzten Satz einer Antwort des Staatsratsvorsitzenden und mächtigsten Mann der DDR, Walter Ulbricht, auf die Frage einer Journalistin der Frankfurter Rundschau in einer Pressekonferenz am 15. Juni 1961 war eine glatte Lüge. Sie klang wie Hohn, als am 13. August 1961 der Bau der Berliner Mauer vor dem Brandenburger Tor und anderen Stellen der innerstädtischen Grenze begann und West-Berlin über Nacht für Ost-Berliner unerreichbar wurde. Sie konnten nicht zu ihren Arbeitsstellen in West-Berlin und auch Verwandte oder Bekannte zu besuchen, wurde für Ost-Berliner und DDR-Bürger fast unmöglich. Unter großem Risiko flohen über die nur provisorisch abgesicherte Grenze allein im August noch über 25.000 Menschen nach West-Berlin. Unter ihnen waren zahlreiche Grenzposten, da diese sich den Absperrungen ungehindert nähern konnten. So auch der Bereitschaftspolizist Conrad Schumann, dessen Sprung über die Stacheldrahtrollen an der Ecke Bernauer und Ruppiner Straße von einen West-Berliner Fotografen dokumentiert wurde. Sein Foto ging um die ganze Welt.

Von Anfang an war der »Antifaschistische Schutzwall« eine Dauerbaustelle und finanziell ein Fass ohne Boden. Schon wenige Tage nach der Grenzschließung begannen Bautrupps die provisorischen Grenzanlagen, bestehend aus Stacheldrahtrollen und Metallgitterzäunen durch eine Mauer zu ersetzen. Diese Mauer der »ersten Generation« bestand meist aus Stahlbetonfertigteilen, die eigentlich für den Wohnungsbau gedacht waren, erhöht durch einige Reihen Hohlblockstein-Mauerwerk. Mehrere Reihen Stacheldraht an Y-Haltern sollten Überklettern verhindern. Mehrmals wurde diese Mauer bei erfolgreichen Fluchtversuchen mit Lastwagen durchbrochen.

Ab 1962 wurde innen entlang der Mauer ein durchgehender Kolonnenweg mit Lichttrasse angelegt. Auf ihm patrouillierten Grenzposten in Fahrzeugen. Im grenznahen Gebiet wurden Anwohner und Passanten kontrolliert, nicht regimetreue Bürger und Bewohner von Häusern unmittelbar an der Grenze zwangsumgesiedelt.

Entlang der Grenze wurden Wachtürme errichtet, anfangs meist aus Holz. 1964 gab es rund um West-Berlin schon 165, die später durch Türme aus Betonfertigteilen ersetzt wurden. 1975 gab es 190 Beobachtungstürme und Führungsstellen, 1989 waren es über 300.

Seit 1965 wurden Häuser in unmittelbarer Grenznähe abgerissen. Selbst vor Kirchen wurde nicht Halt gemacht, wenn sie der lückenlosen Überwachung des Grenzstreifens im Wege standen.

1966 begann die Zeit der »modernen Grenze«, wie sie von den Verantwortlichen gerne genannt wurde. Die Mauer der »ersten Generation« wurde ersetzt durch eine der »zweiten Generation« aus Betonplatten zwischen in den Boden eingelassenen Stahl- oder Betonpfählen mit seitlichen Nuten. Statt des brutalen und symbolhaften Stacheldrahts sollte nun ein von Stahlbändern gehaltenes 40 Zentimeter breites Rohr das Überklettern verhindern, weil sich niemand daran festhalten kann. Ab 1971 wurde im Hinterland ein durchgehender Stacheldrahtzaun errichtet, »Grenzzaun I« genannt. Dieser wurde ab 1974 durch den »Grenzsignalzaun 74« und

most all of the remaining individual farmers where forced into the agricultural production cooperatives (LPG).

The decision to secure the border around West Berlin was finally made at a meeting between Khrushchev and Ulbricht on 3 August 1961 in Moscow, after the Soviet leadership had declined securing the border since the mid-1950s, while the East German leadership increasingly urged to do it.

## CONSTRUCTION OF THE WALL, SECRETLY PREPARED

"Nobody has the intention to erect a wall." This last sentence of a reply by the chairman of the Council of State and the most powerful man in the GDR, Walter Ulbricht, to the question of a journalist of Frankfurter Rundschau in a press conference on 15 June 1961 was an outright lie. It sounded like mockery, as on 13 August 1961, construction of the Berlin Wall began at the Brandenburg Gate and other sections of the inner-city boundary and West Berlin overnight became unreachable for East Berliners. They could not attend their jobs in West Berlin and also visiting relatives or friends became almost impossible for East Berliners and GDR citizens. At great risk fled across the provisionally secured border in August alone more than 25,000 people to West Berlin. Among them were numerous border guards, as they were able to approach the barriers unhindered. So did also the riot policeman Conrad Schumann, whose jump over the barbed wire rolls at the corner of Bernauer and Ruppiner Straße was documented by a West Berlin photographer. His picture went around the world.

From the beginning, the "anti-fascist protective barrier" was in constant state of construction and financially a bottomless pit. Already a few days after the closing of the border, construction crews began to replace the temporary border barriers made of rolls of barbed wire and metal mesh fences by a brick wall. This wall of the "first genera-

tion" consisted mostly of precast reinforced concrete elements, which were meant for housing, increased by a few rows of hollow block masonry. Some rows of barbed wire on Y-holders were to prevent climbing over. Several times this wall has been broken through by lorry in successful escape attempts.

Starting in 1962, a continuous patrol road with floodlights was built along the inner side of the Wall. Border guards in vehicles patrolled on it. In the border area, residents and passers-by were checked, citizens not abiding to the regime and residents of houses directly on the border were forcibly relocated.

Watchtowers were built along the border, initially mostly made of wood. In 1964 there were around West Berlin already 165 of them, which were later replaced by towers made of prefabricated concrete parts. In 1975 there were 190 observation towers and command posts, in 1989 there were over 300.

Since 1965 houses were demolished in the immediate vicinity of the border. Even churches were tore down if they hindered the all-over monitoring of the border strip.

In 1966, the era of "modern frontier" began, as those responsible liked to call it. The wall of the "first generation" was replaced by one of the "second generation", made of concrete slabs between steel or concrete piles with lateral grooves, embedded into the floor. Instead of the brutal and symbolical barbed wire, a 40 cm wide tube held by steel straps should now prevent climbing over, because nobody can hold on to it. From 1971 onwards, a continuous barbed wire fence was erected in the hinterland, called "Border Fence I". This was replaced from 1974 on by the "Border Signal Fence 74" and the "hinterland wall" of concrete slabs between piles. Now there were walls on both sides of the border strip. The patrol road was paved with asphalt or concrete slabs.

From 1976, the "Border Wall 75" was erected, the Wall of the "third generation" made of L-shaped, up to 3.6 metres high concrete segments, topped

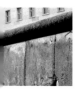

die »Hinterlandsicherungsmauer« aus Betonplatten zwischen Pfählen ersetzt. Der Grenzstreifen war nun beiderseits von Mauern eingefasst. Der Kolonnenweg wurde asphaltiert oder mit Betonplatten befestigt.

Ab 1976 wurde die »Grenzmauer 75« aufgestellt, die Mauer der »dritten Generation« aus L-förmigen, bis zu 3,6 Meter hohen Betonsegmenten, oben mit übergestülptem Rohr, schnell aufzustellen, »wartungsarm und formschön«, und vor allem, noch schwieriger zu überwinden«.

Die Grenze sollte ein freundlicheres, saubereres Erscheinungsbild bekommen. Flächensperren wie die Eisenmatten mit nach oben weisenden Zinken (»Stalinrasen«) und streckenweise Kfz-Gräben wurden entfernt, an repräsentativen Orten wie dem Brandenburger Tor wurden Höckersperren (»Spanische Reiter«) durch bepflanzte Beton-Blumenkübel

ersetzt. Beobachtungstürme und Führungsstellen wurden durch geräumigere aus neuen Betonfertigteilen ersetzt. Ab Mitte der 1980er Jahre wurde der Grenzsignalzaun erneuert.

Als der Staatsratsvorsitzende und SED-Chef Erich Honecker, der Nachfolger Walter Ulbrichts, am 19. Januar 1989 sagte »Die Mauer wird in 50 und auch in 100 Jahren noch bestehen bleiben, wenn die dazu vorhandenen Gründe nicht beseitigt werden.«, ahnte noch niemand, dass die Mauer nicht einmal mehr ein Jahr überdauern würde. Erich Honecker hatte den Mauerbau einst organisiert, als Sekretär für Sicherheitsfragen des Zentralkomitees der SED.

Ab 1989 sollten die Grenzanlagen mit neuer Technik ausgerüstet werden. Mikrowellen- und Infrarotsensoren sollten die Grenze effizienter sichern und langfristig den Schusswaffengebrauch und mechanische Sperren weitgehend ersetzen.

## DER TYPISCHE AUFBAU DER GRENZANLAGEN ZUM SCHLUSS:

1. Grenze
2. »Feindwärtsgebiet«, sogenanntes Unterbaugebiet, das den Sperren vorgelagerte Hoheitsgebiet der DDR (kein »Niemandsland«!), im Stadtgebiet meist ein relativ schmaler Streifen, außer an Gewässern und Bahnstrecken. Die schwarz-rot-gold gestreiften Grenzsäulen mit DDR-Staatswappen gab es um West-Berlin nicht.
3. Vorderes Sperrelement: in Siedlungen eine Stahlbetonfertigteilmauer mit Rohr darauf (*die* Berliner Mauer), sonst ein Streckmetallzaun an Betonpfosten.
4. an durchbruchgefährdeten Stellen: Kfz-Sperrgraben, in Berlin wegen Platzmangels stattdessen oft Höckersperren (»Spanische Reiter«) oder an repräsentativen Stellen wie dem Brandenburger Tor bepflanzte Blumenkübel aus Beton.
5. Kontrollstreifen K 6 aus geharktem Sand, sechs Meter breit, zur Kenntlichmachung von Fußspuren.
6. Der Kolonnenweg, in Berlin asphaltiert, sonst oft aus Lochbetonplatten.
7. Lichttrasse.
8. Schutzstreifen, im Idealfall 500 Meter breit, in Berlin meist deutlich schmaler oder nicht vorhanden, mit Beobachtungstürmen, Führungsstellen und Bunkern.
9. An durchbruchgefährdeten Stellen: Höckersperren (»Spanische Reiter«).
10. Der Signalzaun, ein unter Schwachstrom stehender Drahtzaun, der bei Berührung in der Führungsstelle Alarm auf dem zugehörigen Signalfeld auslöste.
11. Kontrollstreifen K 2, zwei Meter breit, zur Spurensicherung.
12. Hinteres Sperrelement: in Siedlungen meist Stahlbetonplattenmauer, in Berlin oft auch Hauswände, Brandmauern oder Grundstücksmauern; sonst Streckmetallzaun mit Betonpfosten.
13. In schwer einsehbarem und zu kontrollierendem Gelände weiterer Grenzzaun mit Kontrollstreifen, Grenzaufklärern und zusätzlichem Patrouillendienst.

by a tube, fast to erect, "low-maintenance and shapely", and, above all, harder to get over.

The border should get a friendlier, cleaner appearance. Surface barriers such as the iron mats with upward-pointing tines ("Stalin lawn") and some anti-vehicle trenches were removed, in prestigious locations such as the Brandenburg Gate anti-tank barriers ("chevaux-de-frise") were replaced by concrete flower pots with plants. Observation towers and command posts were replaced by more spacious ones made of new precast concrete parts. From the mid-1980s, the border signal fence was renewed.

When the chairman of the State Council and SED leader Erich Honecker, who succeeded Walter Ulbricht, said on 19 January 1989 "The Wall will remain standing in 50 and even in 100 years, if the reasons for it are not yet removed", nobody knew that the wall would not even last for another year. Erich Honecker once had organized the construction of the Wall, as Secretary for Security of the Central Committee of the SED.

From 1989 on, the border facilities were to be equipped with new technology: Microwave and infrared sensors should secure the border more efficiently and largely replace firearms and mechanical barriers in the long term.

## THE TYPICAL STRUCTURE OF THE BORDER INSTALLATIONS IN THE END:

1 Boundary.

2 "Territory towards enemy", so-called outlying territory, the sovereign territory of the GDR off the barriers (no "no-man's land"!), usually narrow in the city area, except at waters and rail routes. There were no black-red-gold striped border columns with GDR coat of arms around West Berlin.

3 Front barrier element: within settlements, a concrete slab wall topped with a tube (the "Berlin Wall"), or expanded metal fence on concrete posts.

4 At sections prone to breakthroughs: anti-vehicle trench, in Berlin instead of that due to lack of space often anti-tank barriers ("chevaux-de-frise") or at prestigious points such as Pariser Platz/Brandenburg Gate, concrete flower pots with plants.

5 Control Strip K 6 of raked sand, 6 metres wide, for the identification of footprints.

6 Patrol road, in Berlin asphalted, elsewhere often made of perforated concrete slabs.

7 Light strip.

8 Protective strip, ideally 500 metres wide, in Berlin considerably narrower or nonexistent, with watchtowers, bunkers and command posts.

9 At sections prone to breakthroughs: anti-tank barriers ("chevaux-de-frise").

10 Border signal fence, a wire fence carrying low voltage, triggering alarm on the corresponding indicator board at the command post when touched.

11 Control strip K 2, 2 metres wide, for securing traces.

12 Rear barrier element: within settlements mostly concrete slab wall, in the centre of Berlin often also house walls, firewalls or property walls; elsewhere expanded metal fence on concrete posts.

13 In terrain hard to observe and difficult to monitor: another fence with control strip and border reconnaissance patrols.

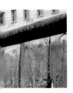

14. Grenzgebiet, im Idealfall fünf Kilometer breit und mit Kontrollstellen an den Zufahrten. In Berlin oft nur angrenzende Grundstücke. Schilder zeigten den Beginn an. Besuch war nur mit Genehmigung auf Antrag erlaubt.

15. Grenznaher Raum, kontrolliert durch die Polizei. Im Autobahn-Abzweig Drewitz (heute Autobahndreieck Nuthetal) beobachtete die Transportpolizei von einem Turm aus den Verkehr. Vor allem achtete sie auf DDR-Fahrzeuge ohne Potsdamer Kennzeichen, die weiter in Richtung West-Berlin fuhren.

Auch in Gewässern, in der Kanalisation und in Tunneln gab es Grenzsperren. Um West-Berlin gab es anders als an der Grenze zur Bundesrepublik Deutschland keine Minen oder Splitterminen (»Selbstschussanlagen«). Dafür gab es an einigen Abschnitten Hundelaufanlagen.

In Berlin wurden wegen der oft schmalen und verwinkelten Grenzanlagen mehr Grenzsoldaten je Grenzlänge eingesetzt als anderswo.

Unmittelbar vor dem Mauerfall gab es zwischen West- und Ost-Berlin sieben Grenzübergänge für Straßenverkehr, einen für Eisenbahnverkehr und drei für Wasserverkehr. Zwischen West-Berlin und dem Umland waren es sechs für Straßenverkehr, drei für Eisenbahnverkehr und fünf für Wasserverkehr. An vielen Grenzübergangsstellen gab es Beschränkungen bezüglich Verkehrsmittel, Status und Staatsangehörigkeit, Zielgebiet oder Abfertigungszeiten.

## GEBIETSAUSTAUSCHE AN DER GRENZE WEST-BERLINS

### 1. ZWISCHEN DER BRITISCHEN UND DER SOWJETISCHEN BESATZUNGSMACHT

Der Flugplatz Gatow wurde von britischen Besatzungstruppen genutzt, lag aber teilweise in der SBZ, ebenso Abschnitte der beiden Hauptverbindungsstraßen zum übrigen West-Berlin, während der Flugplatz Staaken von sowjetischen Besatzungstruppen genutzt wurde, aber teilweise im britischen Sektor von Berlin lag.

Deshalb kamen am 31. August 1945 gemäß Beschluss des Alliierte Kontrollrats vom 30. August 1945

– von der Sowjetischen Besatzungszone (SBZ) zum Britischen Sektor von Berlin:
Teil von Groß Glienicke östlich der Mitte des Groß Glienicker See mit dem größeren Teil des Flugplatz Gatow, und der Seeburger Zipfel nördlich von Gatow, der bis zum Westrand der Straße Scharfe Lanke oberhalb des Havelufers reichte, mit den genannten Hauptverbindungsstraßen und dem Wohngebiet Weinmeisterhöhe, insgesamt 1,72 km²,

– vom Britischen zum Sowjetischen Sektor von Berlin:
West-Staaken mit einem kleinen Teil des Flugplatz Staaken, 5 km².

Es wurde zunächst weiter vom Bezirk Spandau in West-Berlin verwaltet. Am 1. Februar 1951 zog die DDR-Volkspolizei ein und die meisten Einwohner zogen aus, nach West-Berlin. West-Staaken wurde nun vom Stadtbezirk Mitte in Ost-Berlin verwaltet, am 1. Januar 1961 wurde es nach Falkensee eingemeindet, am 1. Januar 1971 wurde es die eigene Gemeinde Staaken im Kreis Nauen.
Am 3. Oktober 1990 kam West-Staaken wieder zum Bezirk Spandau von Berlin, während die anderen Gebiete nicht rückgegliedert wurden.

### 2. ZWISCHEN WEST-BERLIN UND DER DDR

Bei der Eingemeindung am 1. Oktober 1920 waren im Umland zehn Exklaven von Berlin entstanden (aus Sicht des Umlands Enklaven), insgesamt 1,13 km².

14 Frontier area, ideally 5 km wide and with checkpoints on access roads. In Berlin often only adjacent plots. Signs were indicating its beginning. Visits were only allowed with authorization upon application.

15 Region close to the frontier, controlled by the police. (Inside Drewitz motorway junction, today called motorway interchange Nuthetal, transport police watched the traffic from a tower. Especially they looked out for DDR vehicles without Potsdam registration numbers that drove towards West Berlin anyway).

There were barriers also in the waters, in the sewers and in tunnels. Around West Berlin, unlike at the border with the Federal Republic of Germany, there were no mines or fragmentation mines ("spring guns"). Instead, there were dog runs at some border sections.

In Berlin, more border guards per boundary length were deployed than elsewhere, due to the often narrow and winding border installations.

Immediately before the Wall fell, there were between West and East Berlin seven border crossings for road traffic, one for rail traffic and three for water traffic. Between West Berlin and the surrounding area there were six for road traffic, three for rail traffic and five for water traffic.

At many border crossing points, there were restrictions regarding means of transport, status and nationality, destination or opening hours.

## EXCHANGES OF TERRITORY AT THE BORDER OF WEST BERLIN

### 1 BETWEEN THE BRITISH AND THE SOVIET OCCUPYING POWERS

The Gatow airfield was used by British occupation troops, but lay partly in the Soviet zone, as did sections of the two major roads to the rest of West Berlin, while the Staaken airfield was used by Soviet occupation troops, but lay partly in the British sector of Berlin.

Therefore, according to a resolution of the Allied Control Council of 30 August 1945, on 31 August 1945 were transferred

- from the Soviet occupation zone (SBZ) to the British sector of Berlin:

 The part of Groß Glienicke east of the middle of Lake Groß Glienicke with the larger part of the Gatow airfield, and the Seeburg strip north of Gatow, reaching up to the western edge of the street Scharfe Lanke above the bank of the river Havel, with the aforementioned major roads and the Weinmeisterhöhe residential area, a total of 1.72 km²,

- from the British to the Soviet sector of Berlin:

West Staaken with a small part of the Staaken airfield, 5 km².

It was initially still administered by the district of Spandau in West Berlin. On 1 February 1951, East German People's Police moved in and most of the inhabitants moved out, to West Berlin. West Staaken was now administered by the city district of Mitte in East Berlin, on 1 January 1961 it was incorporated into Falkensee, on 1 January 1971 it became a separate municipality in Nauen county, named Staaken.

On 3 October 1990 West Staaken was reintegrated into the Spandau district of Berlin, while the other areas were not returned.

### 2 BETWEEN WEST BERLIN AND THE GDR

With the incorporation on 1 October 1920, ten exclaves of Berlin were created (enclaves from the perspective of the surrounding area), altogether 1,13 km².

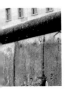

Die Vereinbarungen der Alliierten von 1944 in London zur Besetzung Deutschlands bezogen sich auf die bestehenden Verwaltungsgrenzen. Weil diese Gebiete zufällig alle zu den West-Berliner Bezirken Spandau und Zehlendorf gehörten, waren sie demzufolge von der SBZ umschlossen. Vor allem bei der einzigen dauernd bewohnten Exklave, Steinstücken, führte dies bald zur Konfrontationen von Anwohnern, West-Berliner Behörden und USA-Militär mit der DDR.

Beiderseits an der Sektorengrenze zwischen West- und Ost-Berlin lagen zudem einige Grundstücke, die wegen des Grenzverlaufs kaum nutzbar waren oder Verkehrswege unterbrachen. Aus Sicht der DDR stellte der unübersichtliche Grenzverlauf auch ein Sicherheitsrisiko dar. Aufgrund des Viermächte-Abkommens über Berlin vom 3. September 1971 vereinbarten der Senat von West-Berlin und die Regierung der DDR

Gebietsaustausche in den Jahren 1971/72 und 1988. Diese verbanden die drei ummauerten, grenznahen Exklaven, darunter Steinstücken, mit West-Berlin, gliederten die sieben nicht abgeriegelten, unbebauten, grenzferneren Exklaven in die DDR ein und bereinigten den Grenzverlauf zwischen West- und Ost-Berlin. Weil die zu West-Berlin kommenden Gebiete, insgesamt 1,22 km², größer und wertvoller waren als die abgegebenen Gebiete, insgesamt 1,03 km², erhielt die DDR von West-Berlin jeweils Wertausgleich in Höhe von einigen Millionen DM.

Beide Seiten erklärten in einer Protokollnotiz zur letzten Vereinbarung, seitdem keine Exklaven mehr im jeweils anderen Gebiet zu haben. In einem Protokollvermerk zum Art. I des Einigungsvertrags wurde die Gebietsaustausche zwischen den Bezirken Berlins sowie zwischen Berlin und dem neuen Bundesland Brandenburg bestätigt.

## MAUERFALL

Dass die Berliner Mauer fiel, die innerdeutsche Grenze geöffnet und das geteilte Deutschland am 3. Oktober 1990 in Frieden wiedervereinigt wurde, ist ein Glücksfall der Geschichte. Er ist zum großen Teil den mutigen DDR-Bürgern zu verdanken, die ausgehend von den Montagsgebeten für den Frieden, die vom evangelischen Pfarrer der Leipziger Nicolaikirche, Christian Führer, initiiert wurden und den sich daraus entwickelnden großen Montagsdemonstrationen, zu Hunderttausenden auf die Straße gegangen sind und für mehr Freiheit demonstriert haben. Mit dem Ruf »Wir sind das Volk« haben sie den 150-prozentigen Apparatschiks, der Stasi und dem Militär den Wind aus den Segeln genommen. Man stelle sich vor, dass einer von denen die Nerven verloren und seinen Kohorten den Schießbefehl gegeben hätte. Die friedliche Revolution hätte in einem Blutbad geendet. An weitere, weltweite Reaktionen will man lieber gar nicht denken. Das Potential für einen Konflikt zwischen den Großmächten ist durchaus

vorhanden gewesen. Der friedliche und für die Deutschen glückliche Ausgang dieser Revolution ist sicher auch den politisch Verantwortlichen dieser Zeit zu verdanken, die durch umsichtiges Verhalten und geschicktes Verhandeln viel Druck aus der Situation nahmen. Man erinnere sich an die vielen Botschaftsflüchtlinge, DDR-Bürger, die ihre Urlaubsreise ins benachbarte sozialistische Ausland im Sommer und Herbst 1989 dazu nutzten, zu Tausenden in die Botschaften der Bundesrepublik Deutschland in Prag, Budapest und Warschau zu flüchten. Es war mal wieder eine Abstimmung mit den Füßen. Der damalige Außenminister der Bundesrepublik, Hans-Dietrich Genscher, erreichte am 30. September in Verhandlungen, dass die Flüchtlinge von Prag in verschlossenen Sonderzügen durch die DDR in die Bundesrepublik ausreisen durften. Binnen weniger Tage füllte sich die Botschaft erneut mit ausreisewilligen DDR-Bürgern. Schon da musste man sich fragen, wie lange sich die DDR-Regierung und die Sowjetunion

The agreements of the Allies in 1944 in London about the occupation of Germany based on the existing administrative boundaries. As all these areas belonged accidentally to the West Berlin districts of Spandau and Zehlendorf, they were thus surrounded by the Soviet zone. Especially at the only permanently inhabited exclave, Steinstücken, this soon led to confrontations of local residents, West Berlin authorities and U.S. Military with the GDR. On both sides along the border between West and East Berlin were also some plots that were barely usable or interrupted traffic routes because of the border. From the perspective of the GDR the confusing course of the border presented also a security risk. Based on the Quadripartite Agreement on Berlin of 3 September 1971, the Senate of West Berlin and the GDR government agreed exchanges of territory in 1971/72 and 1988. Those linked the three walled exclaves lying close to the border, including Steinstücken, to West Berlin, incorporated the seven open, undeveloped, remote exclaves into the GDR and adjusted the border between West and East Berlin.

Since the areas coming to West Berlin, totaling 1.22 km², were larger and more valuable than the areas given away, totaling 1.03 km², the GDR received from West Berlin each time value compensations amounting to several million (West) German Marks.

Both sides declared in a protocol note to the last agreement to have no more exclaves in each other's territory ever since. In a protocol note to Article I of the Unification Treaty, the exchanges of territory between the districts of Berlin as well as between Berlin and the new state of Brandenburg were confirmed.

## FALL OF THE WALL

The fact that the Berlin Wall came down, the inner German border was opened and the divided Germany was reunified on 3 October 1990 in peace is a strike of luck in history. It is largely due to the courageous East Germans who, starting from the Monday prayers for peace initiated by the Protestant pastor of Nicolai church in Leipzig, Christian Führer, have taken to the streets by hundreds of thousands in the large Monday demonstrations developing therefrom, demonstrating for more freedom. With the cry of "We are the people" they have taken the wind out of the sails of the 150-percent apparatchiks, the Stasi (state security) and the military. Imagine that one of them would have lost his nerve and given his cohorts the order to fire. The peaceful revolution would have ended in a bloodbath. You won't even think of further worldwide reactions. The potential for conflict between the great powers had been quite present. The peaceful and for the Germans happy outcome of this revolution is certainly also due to the political leaders of the time who took a lot of pressure out of the situation through prudent behaviour and skilful negotiations. Remember the many refugees in the embassies, GDR citizens who used their vacation trip to the neighbouring socialist countries in the summer and autumn of 1989 to flee by thousands to the embassies of the Federal Republic of Germany in Prague, Budapest and Warsaw. Once again it was a vote with their feet. The then foreign minister of the Federal Republic, Hans-Dietrich Genscher, achieved on 30 September in negotiations that the refugees from Prague were allowed to leave in sealed special trains through the GDR to the Federal Republic. Within a few days, the embassy filled again with GDR citizens requesting emigration. Already then, you had to wonder how much longer the GDR government and the Soviet Union would watch this mass exodus? How long would they keep silent, and how would all that go on? It continued

diesen Massenexodus noch anschauen würden. Wie lange halten die noch still und wie soll das alles weitergehen? Es ging weiter mit der Öffnung des eisernen Vorhanges durch Ungarn. Bereits ab April hatte Ungarn seine Grenzzäune abgebaut. Am 27. Juni durchschnitten die Außenminister Ungarns, Gyula Horn, und Österreichs, Alois Mock, symbolisch den Grenzzaun bei Sopron. Bei einer medienwirksamen Veranstaltung an der Grenze gelangten dann am 19. August Hunderte DDR-Bürger nach Österreich. Danach reisten Tausende DDR-Bürger nach Ungarn, um über Österreich in die Bundesrepublik auszureisen, anfangs über die grüne Grenze, ab 11. September offiziell über die Grenzübergänge. Die Fernsehbilder sind unvergessen, die eine lange Karawane von Trabbis, Wartburgs und Ladas zeigten, die sich auf schmalen Landstraßen in Richtung Grenze bewegten. Damit war das Ende der Mauer und der DDR eingeläutet, was zu diesem Zeitpunkt natürlich noch keiner ahnte. Besiegelt wurde das Ende dann schließlich in der berühmten Pressekonferenz vom 9. November 1989, in der das Mitglied des Zentralkomitees der SED Günter Schabowski gefragt wurde, ab wann denn die Reiseerleichterung, die für die DDR-Bürger vorgesehen und am gleichen Tag beschlossen waren, in Kraft treten sollen, und der antwortete, dass es seines Wissens nach sofort sei. Dass dies ein internes Missverständnis war, erfuhr man erst später, denn die DDR hatte wohl nicht geplant, die Grenze von jetzt auf gleich für alle zu öffnen. Doch einmal Ausgesprochenes lässt sich nicht mehr ungesagt machen. Die Ost-Berliner strömten zu Zehntausenden über die Grenzübergänge in den Westteil der Stadt. Diese Lawine konnte weder Ochs noch Esel aufhalten (eine Wortwahl des ehemaligen SED-Chefs und Staatsratsvorsitzenden der DDR, Erich Honecker, in Bezug auf den Sozialismus) und schon gar keine Grenzsoldaten, für die die Grenzöffnung wohl noch überraschender war als für alle anderen.

Ende gut, alles gut? Noch nicht ganz, aber fast. Natürlich gab und gibt es bei so etwas noch nie Dagewesenem Gewinner und Verlierer. Die Verlierer finden die Wiedervereinigung wohl nicht so gelungen, genau wie die Ewiggestrigen, für die das Unrechtsregime der DDR gar nicht so schlecht war. Doch so einfach ist das eben nicht. Es ist klar, dass nach 40 Jahren Leben im »sozialistischen« System mit dessen Indoktrination, Ausbildung und Weltanschauung, diese Unterschiede nicht von heute auf morgen verschwunden sind, nur weil die Mauer nicht mehr existiert. Es wird wohl mindestens noch eine weitere Generation brauchen, bis die Deutschen auch im Kopf ganz wiedervereinigt sein werden. Wie sagt ein asiatisches Sprichwort: »Der Fortschritt ist eine Schnecke, also kriechen wir weiter«. In diesem Sinne, vorwärts und nicht vergessen, eine Schnecke ist zwar langsam, aber sie kann sich nicht rückwärts bewegen.

with the opening of the Iron Curtain by Hungary. As early as April Hungary had dismantled its border fences. On 27 June, the foreign ministers of Hungary, Gyula Horn, and Austria, Alois Mock, symbolically cut through the border fence near Sopron. In a media event at the border on 19 August hundreds of East Germans managed to get to Austria. After that, thousands of East Germans traveled to Hungary to emigrate to West Germany via Austria, initially across the green border, since 11 September, officially through the border crossings. Television pictures are unforgotten, showing a long caravan of Trabants, Wartburgs and Ladas, which moved on narrow country roads towards the border. This ushered in the end of the Wall and the GDR, which of course nobody would have guessed at that time. The end finally was sealed then in the famous press conference on 9 November 1989 in which the member of the Central Committee of the SED Günter Schabowski was asked from when travel facilitations provided for the citizens of the GDR and decided on the same day, were to enter force, and he replied that to his knowledge, immediately. That this was an internal misunderstanding, one only learned later, because the GDR had probably not planned to open the border for everybody without a moment's notice. But once said cannot be made unsaid. The East Berliners flocked in tens of thousands over the border crossings into the Western part of the city. This avalanche could neither ox nor donkey stop (a diction of former SED leader and chairman of the State Council of the GDR, Erich Honecker, relating to socialism) and certainly no border guards, for whom the opening of the border was probably more surprising than for any other.

All is well that ends well? Not quite, but almost. Of course, there were and are winners and losers in something like this never seen before. The losers may find the reunification not so successful, as do the diehards, for whom the unjust regime of the GDR was not so bad. But that's just not so simple. It is clear that after living for 40 years in the "socialist" system with its indoctrination, schooling and ideology, these differences did not disappear overnight just because the Wall no longer exists. It will probably still need at least another generation, until the Germans will be fully reunited in their minds. As an Asian proverb says: "The progress is a snail, so we crawl on." In this sense, forward and not forgotten, a snail is slow, but it cannot move backwards, it has no rear gear.

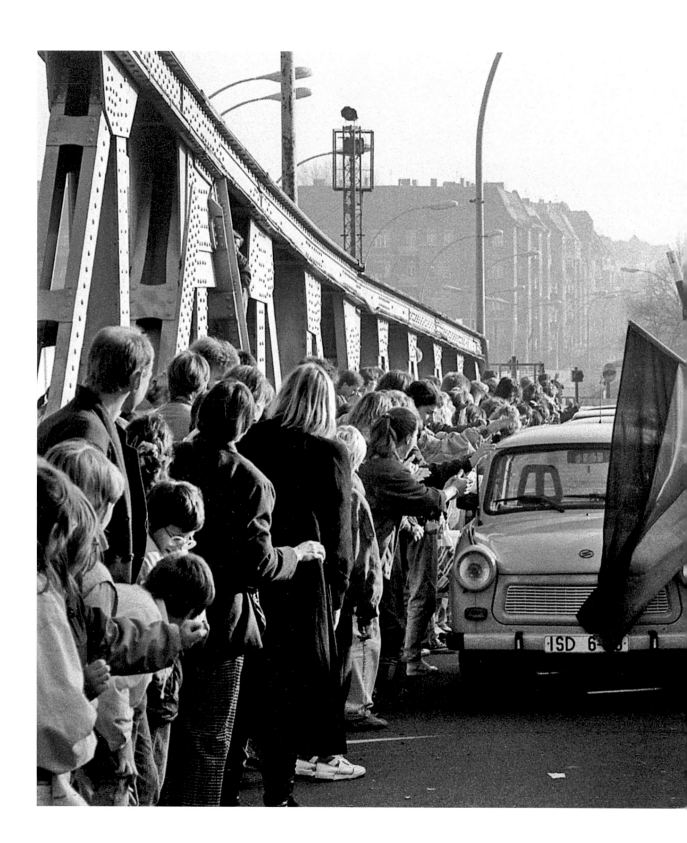

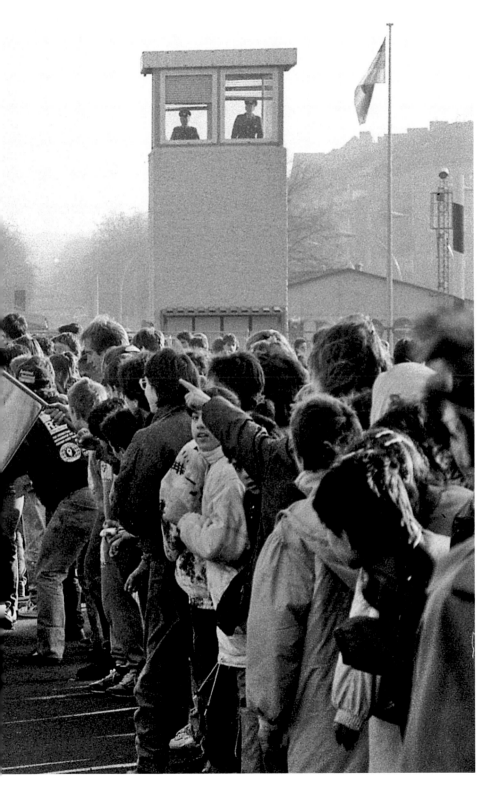

Am 10. November 1989, dem
ersten Tag nach dem Mauerfall,
strömen Tausende Ost-Berliner
über die Grenze. Spalier stehende
West-Berliner begrüßen über-
schwänglich jeden Passanten
und jedes Fahrzeug aus dem
Osten. Janz Berlin is eene Wolke
und in Sektlaune.

On 10 November 1989, the first day
after the fall of the Wall, thou-
sands of East Berliners cross the
border. West Berliners standing in
rows are effusively welcoming each
pedestrian and vehicle from the
East. The whole of Berlin is a cloud
and in sparkling humor.

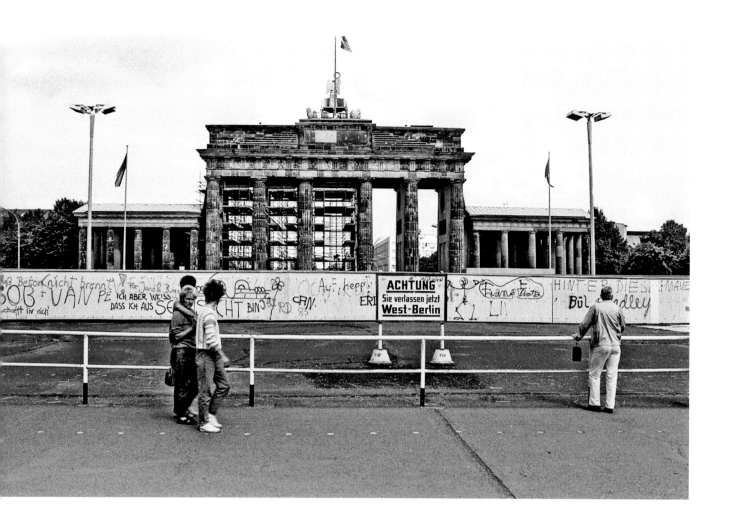

*Die Mauer am Brandenburger Tor, 1986*

Der Platz vor dem Brandenburger Tor bildete seit 1920 die Grenze zwischen den Bezirken Mitte und Tiergarten, seit 1945 die Grenze zwischen sowjetischem und britischem Sektor. Hier begann am frühen Morgen des 13. August 1961 der Bau der Mauer.

*The Wall at the Brandenburg Gate, 1986*

From 1920 onwards the square in front of the gate formed the border between the districts of Mitte and Tiergarten. After 1945 it was the border between the Soviet and British sectors. The Wall was started here in the early hours of 13 August 1961.

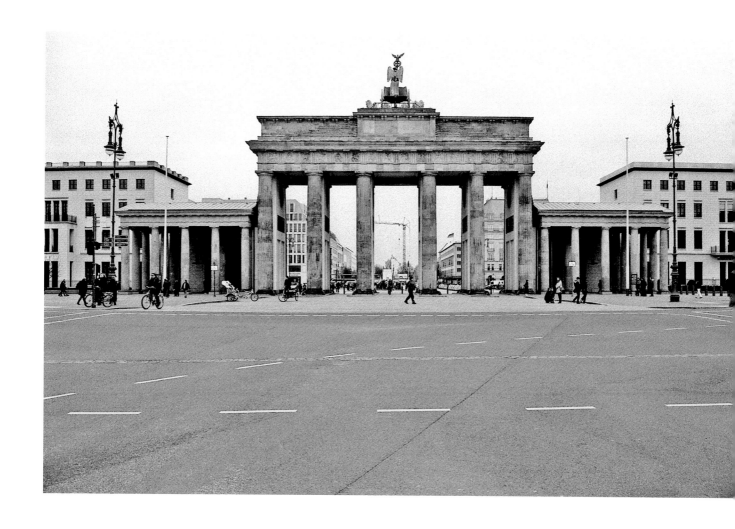

*Blick von Westen auf das Brandenburger Tor, 2009*

Mit dem Abbruch der Mauer ist aus dem Branden-
burger Tor wieder ein tatsächliches Tor geworden.
Solange die Mauer existierte, war dies der weltweit
prominenteste Ort der Stadt: kein Wunder, dass
er jetzt zum obligaten Empfangsort bei Staats-
besuchen geworden ist.

*Looking east through the Brandenburg Gate, 2009*

When the Wall was removed the gate again be-
came a thoroughfare. During the Wall years this
was the city's most famous sight; not surprising
that all state visitors are now officially welcomed
here.

33

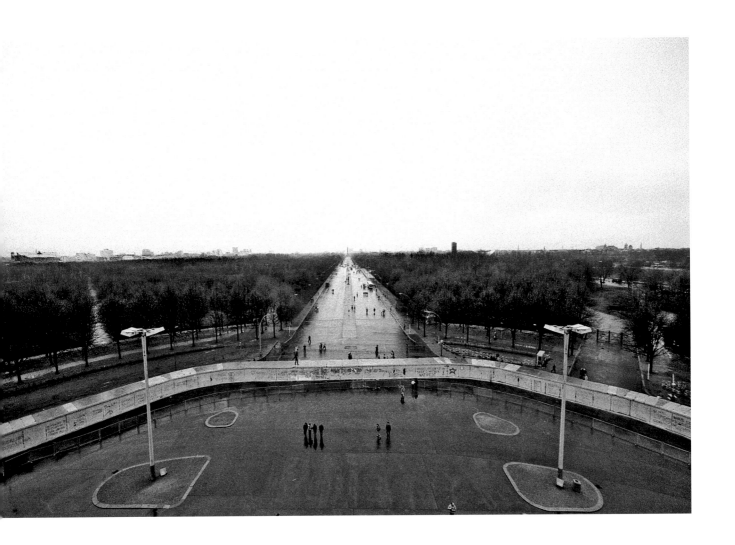

*Blick vom Brandenburger Tor in Richtung Westen, 1990*

Kurz vor dem Abbruch der Mauer vom Dach des Brandenburger Tores aufgenommen, zeigt das Bild den hier der halbrunden Form des Vorplatzes angepassten Verlauf der Mauer. In der Bildmitte verläuft die Straße des 17. Juni quer durch den Tiergarten.

*Looking west from the Brandenburg Gate, 1990*

Taken from the top of the Brandenburg Gate shortly before the dismantling of the Wall, this photograph shows the semi-circular borderline it followed. In the centre the Straße des 17. Juni cuts through the Tiergarten park.

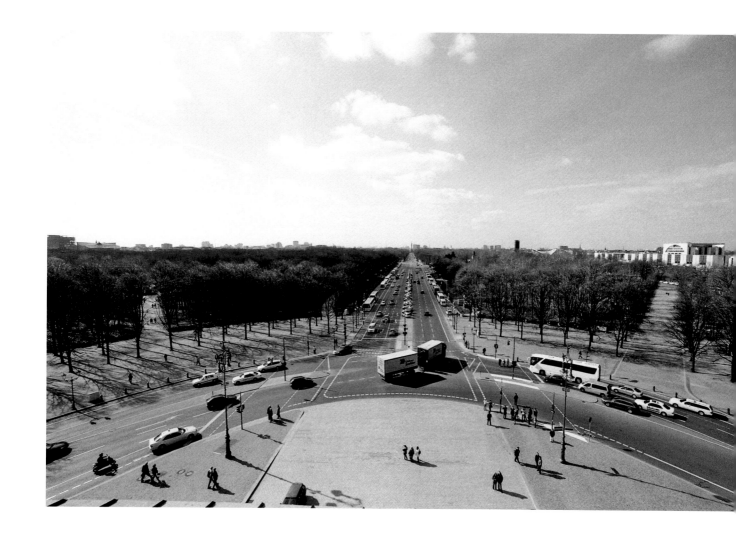

*Blick vom Brandenburger Tor in Richtung Westen, 2007*

*Looking west from the Brandenburg Gate, 2007*

Der Fall der Mauer ermöglichte die Neugestaltung des Stadtraums. Wo 30 Jahre lang Niemandsland lag, wurde der »Platz vor dem Brandenburger Tor« als Verkehrsknotenpunkt wiederhergestellt. Seit Mai 2002 ist das Brandenburger Tor für den motorisierten Verkehr gesperrt. Rechts im Bild das Bundeskanzleramt, erbaut im Stil der Postmoderne von den Architekten Axel Schultes und Charlotte Frank in den Jahren 1997 bis 2001, eröffnet am 1. Mai 2001.

After the fall of the Wall, reconstruction of city space began. The square in front of the Brandenburg Gate, no-man's-land for thirty years, was reconstructed as a traffic hub. Since May 2002, the Brandenburg Gate is closed to motorized traffic. On the right, the Federal Chancellery, built in post-modernist style by the architects Axel Schultes and Charlotte Frank in the years 1997 to 2001, opened on 1 May 2001.

35

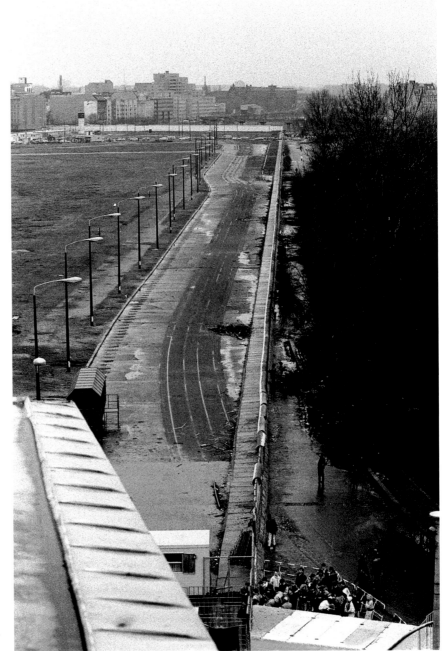

*Blick vom Brandenburger Tor in Richtung Potsdamer Platz, 1990*

*Die Straße vom Brandenburger Tor zum Potsdamer Platz entstand erst 1867. Seit 1925 hieß sie Friedrich-Ebert-Straße, 1933 Hermann-Göring-Straße, ab 1945 wieder Ebertstraße. Nach 1961 wurde sie Teil des Todesstreifens.*

*View from the Brandenburg Gate towards Potsdamer Platz, 1990*

*The street from the gate to Potsdamer Platz was built in 1867. It was named Friedrich-Ebert-Straße in 1925, Hermann-Göring-Straße in 1933, and Ebertstraße in 1945. From 1961 on, it formed part of the death strip.*

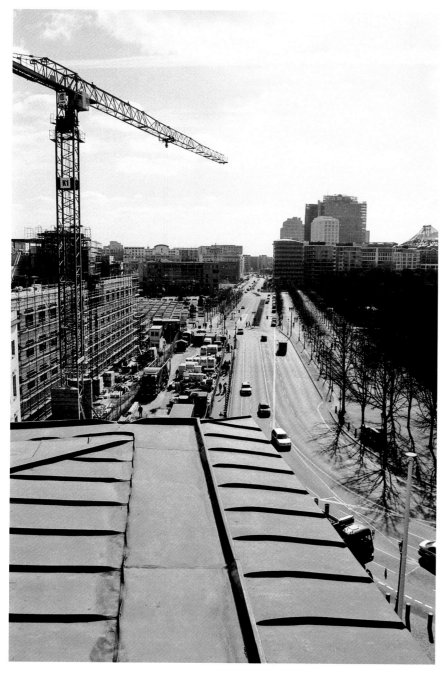

*Blick vom Brandenburger Tor in Richtung Potsdamer Platz, 2007*

*Die Ebertstraße wurde kurz nach dem Mauerfall wiederhergestellt. Zur Umfahrung des Brandenburger Tors wurde die Behrenstraße (links der Bildmitte) durch die ehemaligen Ministergärten hinaus verlängert. Die Botschaft der USA (links) ist das als letztes wieder errichtete Haus am Platz. Der Entwurf stammt vom Architektenbüro Moore Ruble Yudell, Baubeginn war im Oktober 2004. Am 4. Juli 2008, dem US-amerikanischen National-feiertag, wurde die Botschaft im Beisein von Präsident George W. Bush und Bundeskanzlerin Angela Merkel eröffnet.*

*View from the Brandenburg Gate towards Potsdamer Platz, 2007*

*Ebertstraße was rebuilt shortly after the fall of the Wall. To circum-vent the gate, Behrenstraße (left of the image centre) was extended through the former ministerial gar-dens. The embassy of the USA (left) is the last house being rebuilt here. The design was by the architects Moore Ruble Yudell, construction began in October 2004. Opening was on Independence Day, July 4, 2008, in the presence of President George W. Bush and Federal Chancellor Angela Merkel.*

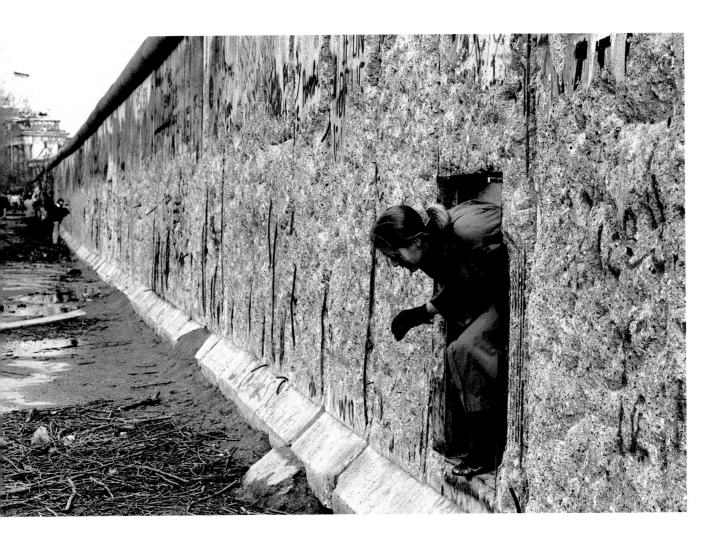

*Die Mauer entlang der Friedrich-Ebert-Straße, 1990*

*Südlich vom Brandenburger Tor (oben links) zwischen dem Tiergarten und der stillgelegten Ebertstraße verlaufend, sieht man die Mauer, von zahlreichen »Mauerspechten« heimgesucht, kurz vor ihrer Abtragung; rechts ein ehemaliger Durchlass der DDR-Grenztruppen.*

*The Wall along Ebertstraße, 1990*

*To the south of the Brandenburg Gate (upper left), between the Tiergarten and the disused Ebertstraße: the Wall, already pock-marked by "Wall woodpeckers", awaits demolition; on the right, an old inspection door once used by GDR border troops.*

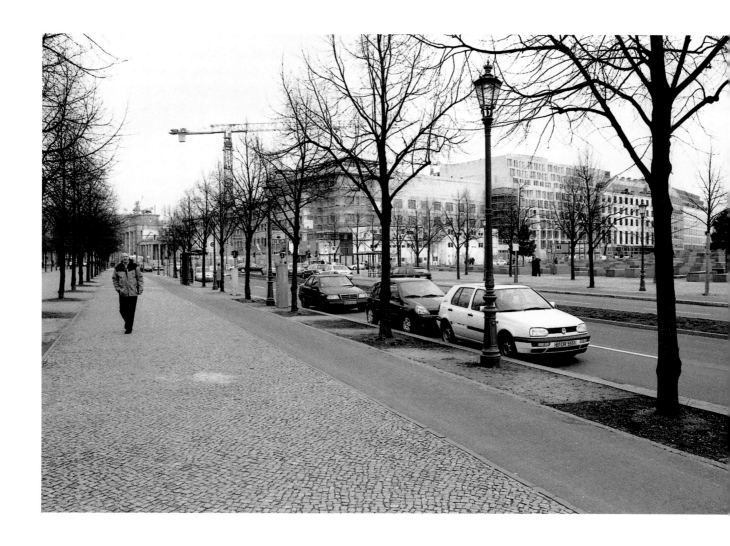

*Die wiedererstandene Ebertstraße, 2007*

Die Bebauung an Ebert- und Behrenstraße ist wieder
geschlossen. Als letztes Haus hier wird die Botschaft
der USA wieder errichtet (2004–2008). Rechts das
Stelenfeld des Holocaust-Mahnmals.

*The reconstructed Ebertstraße, 2007*

The buildings along Ebertstraße and Behrenstraße form
a closed front again. The last house being rebuilt here
is the embassy of the USA (2004–2008). On the right,
the field of stelae of the Holocaust Memorial.

39

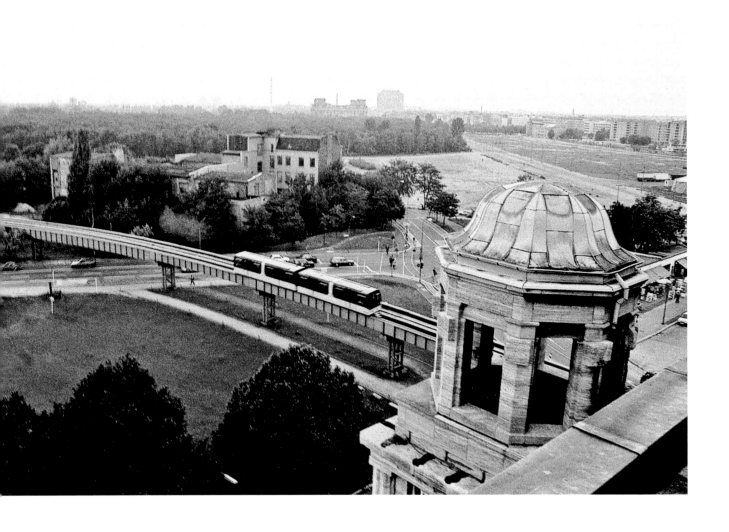

Am Südostrand des Tiergartens, 1991

Nach dem Bau der Mauer verödete hier das einstige
innerstätische Areal auf beiden Seiten. Blick nach Norden
vom Dach des Weinhauses Huth, dem einzigen Haus am
Potsdamer Platz, das die Bombardierungen im zweiten
Weltkrieg überstanden hat: In der Bildmitte die Teststrecke
der Magnetbahn, die vom Bahnhof Gleisdreieck bis zum
Kemperplatz verlief, dahinter die Überreste des einstigen
Hotels Esplanade, dann der Tiergarten. Am Horizont das
Reichstagsgebäude, seit 1954 ohne Kuppel, und rechts
daneben das Bettenhochhaus der Charité. Hinten rechts
der ehemalige Todesstreifen.

On the south-east edge of the Tiergarten, 1991

After the erection of the Wall a wasteland emerged on
both sides. Looking north from the roof of Weinhaus
Huth, the only house at Potsdamer Platz, that survived
the bombardments in World War II: In the centre, the
test track of the magnetic train, running from Gleis-
dreieck Station to Kemperplatz, behind it, the remains
of the former Hotel Esplanade, then the Tiergarten
park. On the horizon, the Reichstag building since
1954 without dome, and to the right, the ward tower
of the Charité hospital. On the rear right, the former
death strip.

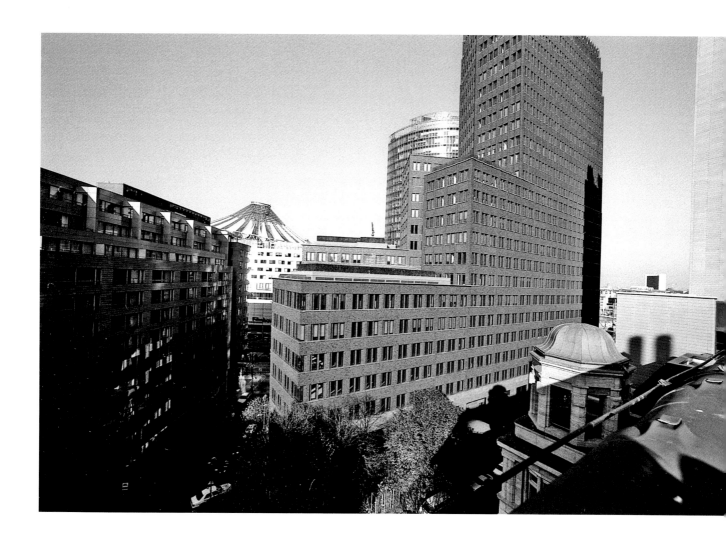

*Am neuen Potsdamer Platz, 2002*

Die westlich vom Potsdamer Platz in wenigen Jahren errichteten neuen Büro- und Geschäftshäuser sind aus dem Nichts entstanden: Die Innenstadt aus der Retorte ist an die Stelle der Stadtbrache getreten, selbst die Varian-Fry-Straße (vorne links, zum Sony Center führend) ist eine Neuschöpfung.

*The new Potsdamer Platz, 2002*

The new business, office and retail buildings west of Potsdamer Platz did not rise out of ruins but were built from scratch within a few years. The "inner city from the lab" has replaced the urban wasteland, and even Varian-Fry-Straße (left foreground, leading to the Sony Center) is a new creation.

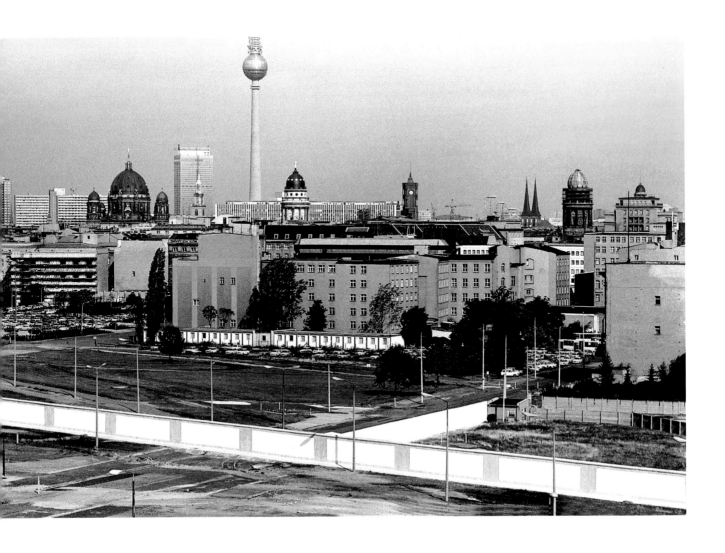

*Der Leipziger Platz vor der Silhouette des alten Stadt-*
*zentrums, 1984*

*Am Horizont fast alle Kirchtürme, die seit jeher die*
*Berliner »Stadtkrone« bilden, Rathaus- und Stadthaus-*
*turm sowie zu DDR-Zeiten errichtete Bauwerke wie*
*der Fernsehturm und das Hochhaus des Hotels Stadt*
*Berlin. Die Hinterlandmauer zerschneidet den Leipziger*
*Platz und riegelt die zur Sackgasse gewordene Leipziger*
*Straße ab.*

*Leipziger Platz against the silhouette of the historical*
*city centre, 1984*

*The horizon shows almost all the church spires forming*
*the city's "crown", the towers of town hall and city hall*
*and various buildings from GDR times, like the Televi-*
*sion Tower and the high-riser of the Hotel Stadt Berlin.*
*The inner wall cuts across Leipziger Platz reducing*
*Leipziger Straße to a dead-end street.*

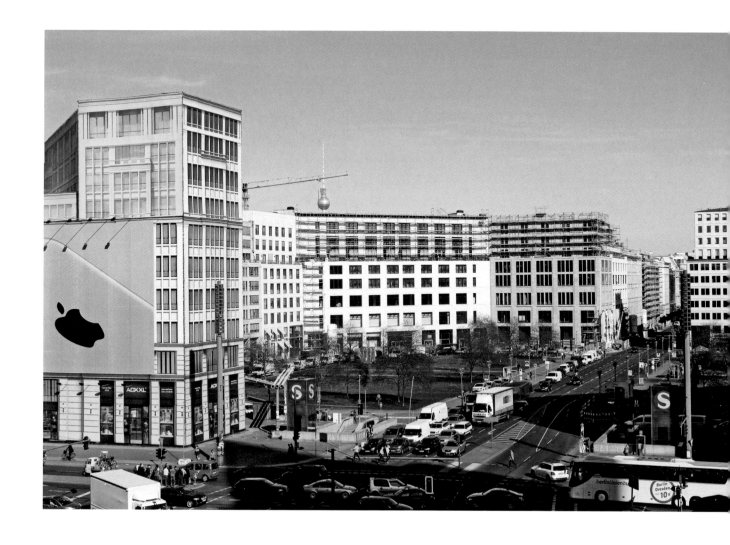

*Der wiedererstandene Leipziger Platz, 2014*

Mit Fertigstellung der Gebäude (Bildmitte) auf dem
Areal des ehemaligen Warenhauses Wertheim ist der
Leipziger Platz, ehemals »Achteck« oder »Octogon«
genannt, wieder vollständig umbaut. Von der alten
Stadtsilhouette ragt nur noch der Fernsehturm am
Alexanderplatz über die Neubauten.

*The reconstructed Leipziger Platz, 2014*

With the completion of the buildings (centre) on the
site of the former Wertheim department store, the
Leipziger Platz, formerly named "Octagon", is com-
pletely surrounded again. Only the Television Tower at
Alexanderplatz rises above the new buildings.

43

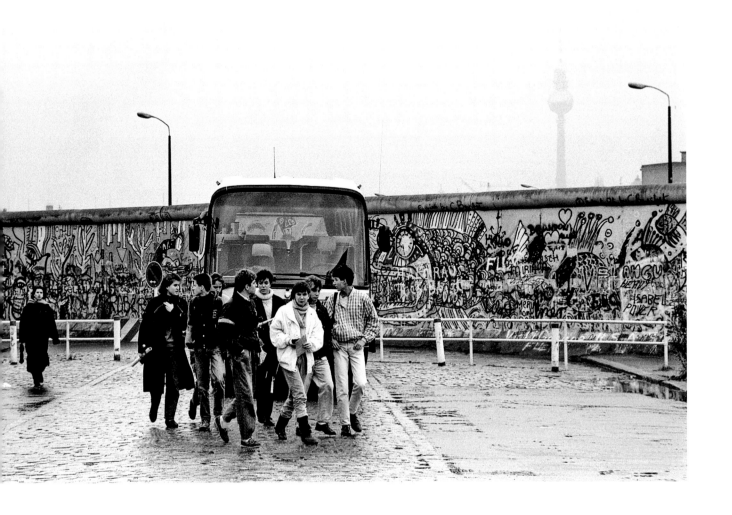

*Die Mauer am Potsdamer Platz, 1987*

Der Potsdamer Platz war eines der beliebtesten Ziele des »Mauertourismus« auch bei jüngeren Leuten, wohl der Handgreiflichkeit des Kontrastes wegen, der sich zwischen »damals« und »heute« herstellen ließ, und der teilweise recht ansehnlichen Mauer-Graffiti.

*The Wall at Potsdamer Platz, 1987*

Potsdamer Platz was one of the most popular features in the "Wall tourist's" programme. Young people in particular were drawn by the palpable contrast between "then" and "now" as well as the often highly imaginative Wall graffiti.

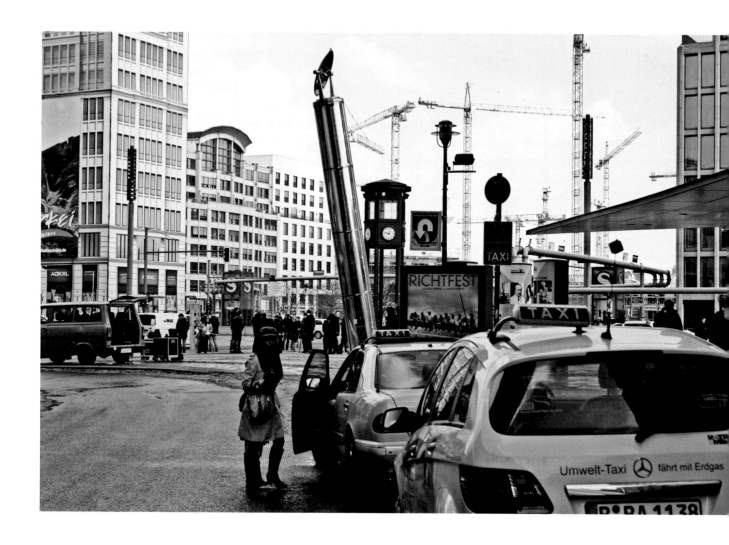

*Blick über den Potsdamer Platz zum Leipziger Platz,
2013*

*View across Potsdamer Platz towards Leipziger Platz,
2013*

Statt nur bis zur Mauer geht der Blick nun weiter auf
die neuen Häuser am Leipziger Platz: links das »Kanada
Haus« mit der kanadischen Botschaft, rechts davon
das »Mosse-Palais«. Hinter diversen Stadtmöbeln
auf dem Potsdamer Platz, wie dem rekonstruierten
Verkehrsturm (Bildmitte), die letzte Großbaustelle der
Umgebung auf dem Areal des ehemaligen Waren-
hauses Wertheim.

Instead of only up to the wall, the gaze wanders further
to the new houses on Leipziger Platz: On the left, "Ca-
nada House" with the Canadian Embassy, to the right
of it, the "Mosse-Palais". Behind various street furniture
on Potsdamer Platz, like the reconstructed traffic tower
(centre), the last major construction in the vicinity on
the site of the former Wertheim department store.

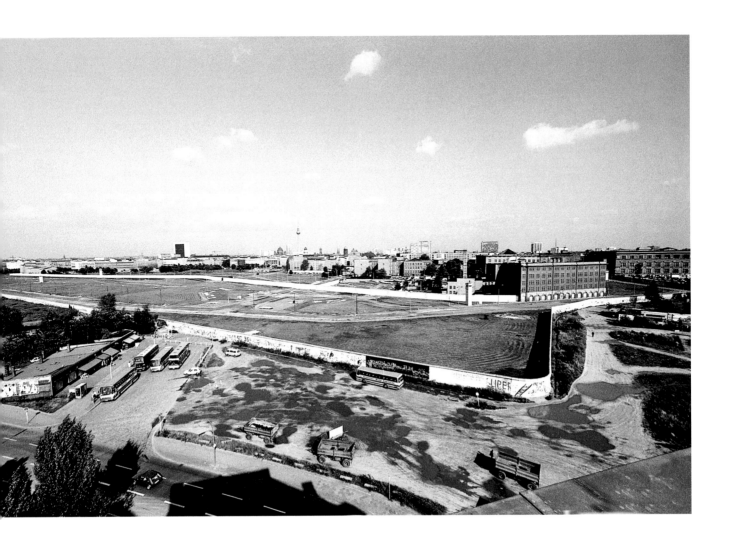

Mauer und Todesstreifen zwischen Brandenburger Tor und Stresemannstraße, 1984

Die Aufnahme zeigt anschaulich, dass – wo immer möglich – der Todesstreifen von einer Außen- und einer Innenmauer eingefasst wurde. Links im Bild, wo die Busse die Mauertouristen ablieferten, ist das letzte Stück der Potsdamer Straße erkennbar.

The Wall and the death strip between the Brandenburg Gate and Stresemannstraße, 1984

This picture clearly shows how, wherever possible, the death strip was flanked by an outer and an inner wall. The tourist buses on the left are parked on the last remaining section of Potsdamer Straße.

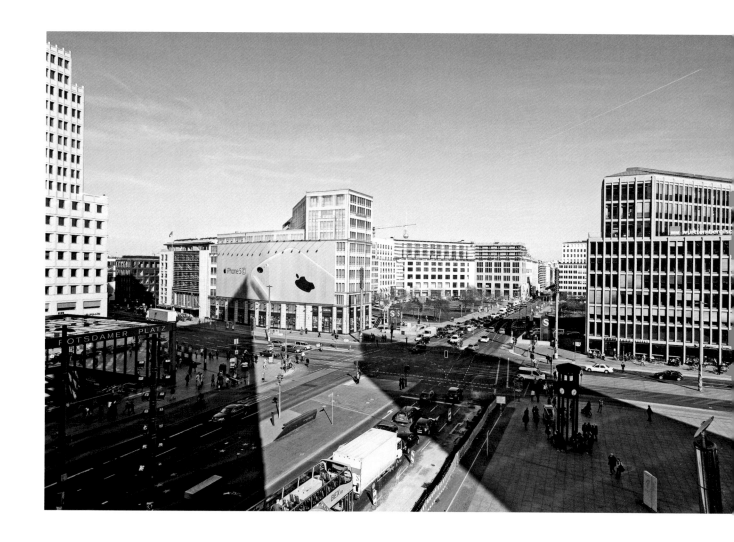

*Nordwest-Südost-Panorama: Potsdamer und Leipziger Platz, 2014*

*North-west/South-east panorama: Potsdamer and Leipziger Platz, 2014*

Die Bebauung an Potsdamer und Leipziger Platz ist nun wieder vollständig. Einzig verbliebener Orientierungspunkt für historische Vergleiche: der Fernsehturm, winzig klein im Hintergrund.

The development at Potsdamer Platz and Leipziger Platz is now complete again. The only remaining point of orientation for historical comparisons is the Television Tower, here a tiny pin in the background.

47

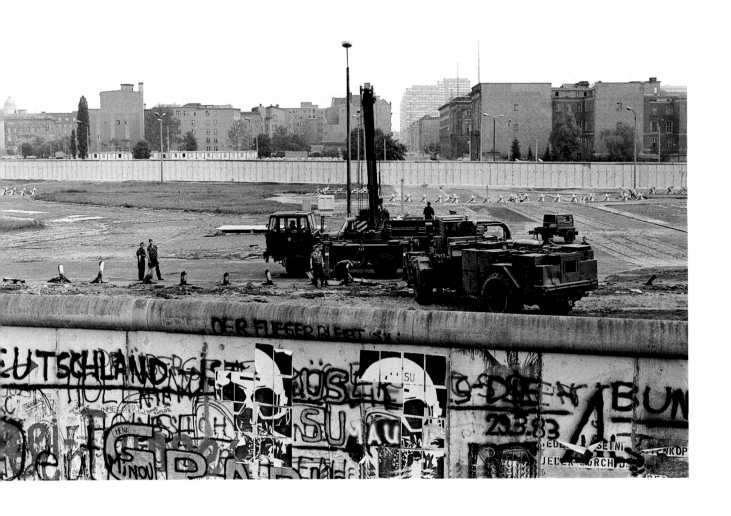

Blick über die Mauer am Potsdamer Platz in die Leipziger Straße, 1984

Jenseits der Mauer sind die DDR-Grenztruppen damit beschäftigt, mit dem Aufstellen von spanischer Reitern (Panzersperren) die »moderne Grenze« auf den Stand der aktuellen Technik zu bringen. Der »innere« Mauer zieht sich über die Leipziger Straße (rechts von der Bildmitte), etwa dort, wo einst das Warenhaus Wertheim stand.

Looking over the Wall at Potsdamer Platz into Leipziger Straße, 1984

On the border strip GDR border troops are busy adding antitank barriers to the latest technical gadgets on the "modern border". In the background the "inner" wall cuts across Leipziger Straße (upper right) close to where the famous Wertheim department store once stood.

*Blick in die Leipziger Straße vom Potsdamer Platz, 2013*

*View along Leipziger Straße from Potsdamer Platz, 2013*

Einst wanderten hier die Blicke über die Mauer hin zu den trostlosen Resten der Berliner City. Nun ist die Bebauung hier wieder vollständig, sobald auch die Neubauten an Stelle des einstigen Warenhauses Wertheim fertiggestellt sind.

Once this would have been the view, across the Wall, of the desolate remains of the city centre of Berlin. Now the development here is complete again once the new buildings at the site of the former department store Wertheim will be finished.

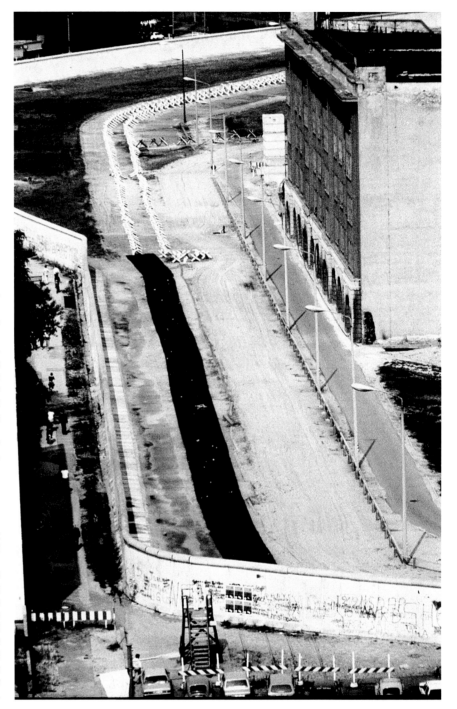

*Die Mauer zwischen Potsdamer Platz und Niederkirchnerstraße, 1981*

*Der Mauerverlauf ist hier identisch mit dem Nordwestende der Stresemannstraße und deren Einmündung in den Potsdamer Platz. Bis zu diesem Punkt stand die DDR-Mauer etwa auf der Trasse der Zoll- und Akzisemauer von 1735. Einzig verbliebenes Haus ist hier der Erweiterungsbau des Preußischen Landwirtschaftsministeriums.*

*The Wall between Potsdamer Platz and Niederkirchnerstraße, 1981*

*The course of the Wall here is identical with the north-west end of Stresemannstraße and its junction with Potsdamer Platz. Up to this point the GDR Wall followed virtually the same route as the customs and excise wall of 1735. The only remaining house here is the extension of the Prussian Ministry of Agriculture.*

*Die Stresemannstraße zwischen Potsdamer Platz und Nieder-kirchnerstraße, 2007*

**Nach dem Fall der Mauer konnte der durchgehende Straßenzug Ebertstraße – Stresemannstraße wiederhergestellt werden. Er führt vom Brandenburger Tor über den Potsdamer Platz zum Mehring-platz.**

*Stresemannstraße between Pots-damer Platz and Niederkirchner-straße, 2007*

*Once the Wall had gone, Ebertstra-ße and Stresemannstraße were reconnected. This road stretches from the Brandenburg Gate across Potsdamer Platz to Mehringplatz.*

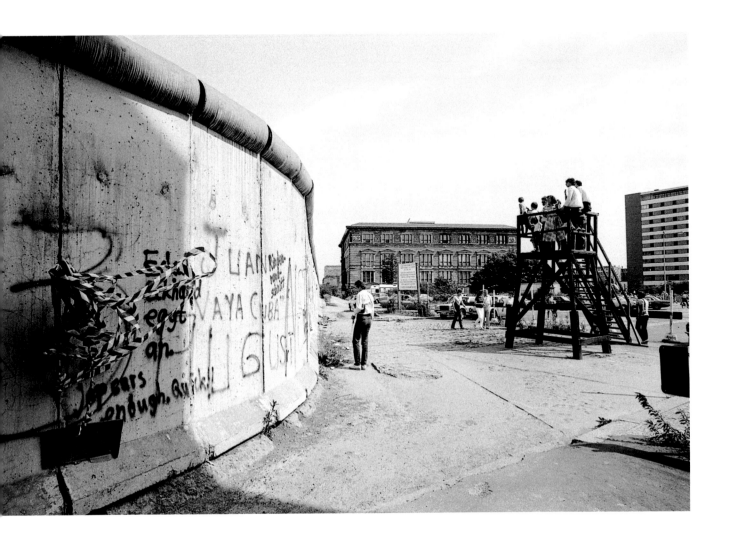

*Die Mauer entlang der Niederkirchnerstraße, 1981*

Die Niederkirchnerstraße, auf deren südlichem Gehweg
die Mauer verläuft, hieß einst Prinz-Albrecht-Stra-
ße. 1933 war die Gestapo-Zentrale an dieser Straße
untergebracht worden. In der Bildmitte das ehemalige
Kunstgewerbemuseum (1877–1881, Architekten Martin
Gropius und Heino Schmieden), nun Martin-Gropius-
Bau, rechts das Europahaus (um 1930, Architekt Otto
Firle).

*The Wall along Niederkirchnerstraße, 1981*

Niederkirchnerstraße, where the Wall runs on its
southern walkway, was once named Prinz-Albrecht-
Straße. 1933, the Gestapo headquarters was located on
this street. In the centre, the former Museum of Applied
Arts (1877–1881, architects Martin Gropius and Heino
Schmieden), now Martin-Gropius-Bau, to the right, the
Europahaus (around 1930, architect Otto Firle).

*Die Niederkirchnerstraße von der Stresemannstraße aus, 2009*

Den einstigen Verlauf der Mauer markiert nun eine Doppelreihe Pflastersteine entlang der wieder in ihrer ganzen Breite nutzbaren Niederkirchnerstraße.
Vorher durch die Mauer verdeckt, sind links zu sehen der ehemalige Preußische Landtag, nun Berliner Abgeordnetenhaus, und weiter hinten das ehemalige Reichsluftfahrtministerium, zu DDR-Zeiten Haus der Ministerien, nun Bundesfinanzministerium.

*Looking down Niederkirchnerstraße from Stresemann-straße, 2009*

The former route of the Wall is now marked by a double row of cobblestones along Niederkirchnerstraße, the whole width of which is usable again.
Previously hidden by the Wall on the left are visible the former Prussian Parliament, now Berlin Chamber of Deputies, and further back the former Reich Ministry of Aviation, during the GDR era House of Ministries, now Federal Ministry of Finance.

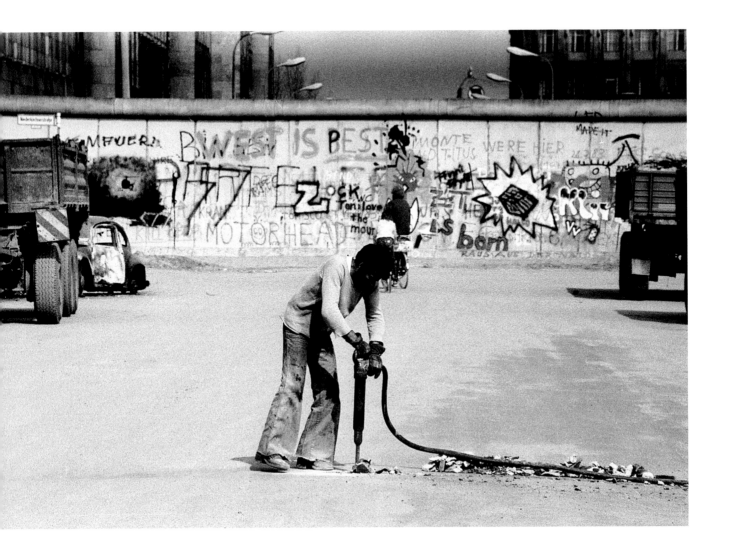

*Die Mauer an der Wilhelmstraße, 1984*

*Die Straße, die durch die Mauer zerschnitten wurde,
hieß auf der Kreuzberger Seite auch nach 1945 Wilhelm-
straße, auf Ost-Berliner Seite hingegen (bis zu ihrer
Rückbenennung 1993) Otto-Grotewohl-Straße, um die
Erinnerung an ihre Tradition als preußisch-deutsche
Regierungsmeile zu tilgen.*

*The Wall at Wilhelmstraße, 1984*

*This street, severed by the Wall, kept the name of
Wilhelmstraße on the Kreuzberg side after 1945. On the
East Berlin side it was renamed Otto-Grotewohl-Straße
(until 1993) in an effort to eradicate its traditional asso-
ciation with the power centres of Prussian rule.*

*Die Kreuzung Wilhelmstraße / Zimmerstraße, 2014*

Von den Regierungsgebäuden an der Westseite der
Wilhelmstraße ist lediglich das 1935–1936 errichtete
Reichsluftfahrtministerium erhalten geblieben. Wo bis
1990 die Mauer die Wilhelmstraße durchschnitt, ist der
Weg Richtung Unter den Linden wieder frei.

*The junction of Wilhelmstraße and Zimmerstraße, 2014*

Of all the government buildings on the west side of
Wilhelmstraße, only the Reich Ministry of Aviation,
built 1935–1936, remained intact. Where until 1990
the Wall cut across Wilhelmstraße, the street towards
Unter den Linden is open again.

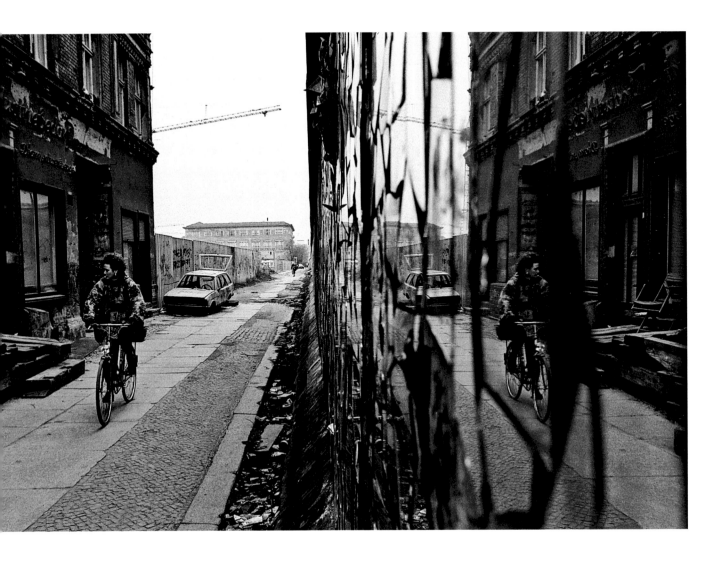

*Die Mauer entlang der Zimmerstraße, 1989*

*Der Blick geht nach Westen die Zimmerstraße und ihre Verlängerung, die Niederkirchnerstraße, entlang an der Mauer, die hier an der südlichen Bordsteinkante verlief, zum Martin-Gropius-Bau (hinten links), 1981 neu als Ausstellungshaus eröffnet. Aktionskünstler der Wall-StreetGallery gegenüber der Mauer haben sie mosaikartig mit Spiegelscherben beklebt, um sie durchsichtig zu machen.*

*The Wall along Zimmerstraße, 1989*

*Looking west along the Wall down Zimmerstraße and its continuation, Niederkirchnerstraße. Here the Wall ran along the southern curbstone towards Martin-Gropius-Bau (rear left) which became an exhibition centre in 1981. Conceptual artists from the Wall-StreetGallery opposite the Wall have pasted it up with a mosaic of mirror fragments to make it transparent.*

*Die Zimmerstraße zwischen Wilhelm- und Friedrich-
straße, 2014*

*Der Martin-Gropius-Bau ist durch einen erst nach dem
Mauerfall errichteten Neubaukomplex verdeckt. Jen-
seits der Wilhelmstraße ist nun das ehemalige Reichs-
luftfahrtministerium, jetzt Bundesfinanzministerium,
zu sehen.*

*Zimmerstraße between Wilhelmstraße and Friedrich-
straße, 2014*

*The Martin-Gropius-Bau is hidden by a new housing
complex built after the fall of the Wall. On the opposite
side of Wilhelmstraße, the former Reich Ministry of Avi-
ation, now Federal Ministry of Finance, became visible.*

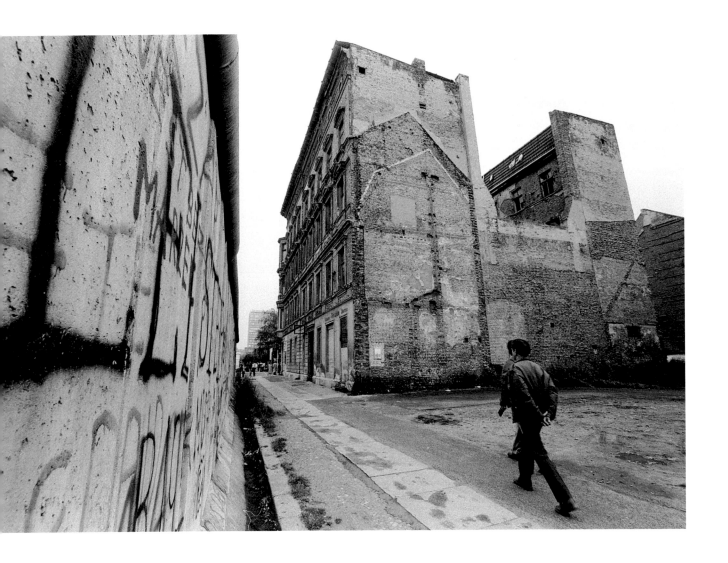

Die Zimmerstraße am Checkpoint Charlie, 1984

Die Zimmerstraße gehörte in voller Breite zum
»Ost«-Bezirk Mitte. Wie an den meisten anderen
Stellen der Grenze war jedoch das zum »Westen« hin
gewandte »vordere Sperrelement«, die Mauer, leicht
zurückgesetzt von der tatsächlichen Grenzlinie
errichtet worden.

Zimmerstraße at Checkpoint Charlie, 1984

The whole width of Zimmerstraße belonged to the
"Eastern" district of Mitte. As in most other sections of
the border, the "West"-facing "outer barrier element",
that is the Wall, was set slightly back from the actual
border line.

*Die Zimmerstraße von der Wilhelmstraße aus, 2014*

Ohne die Mauer ist links einer der wenigen auf der Nordseite der Zimmerstraße, also im Bezirk Mitte, erhalten gebliebenen Gebäudekomplexe (Hausnummern 86–91) zu sehen.

*Looking down Zimmerstraße from Wilhelmstraße, 2014*

Without the Wall, one of the few surviving building complexes (nos. 86–91) on the north side of Zimmerstraße in the district of Mitte has become visible.

59

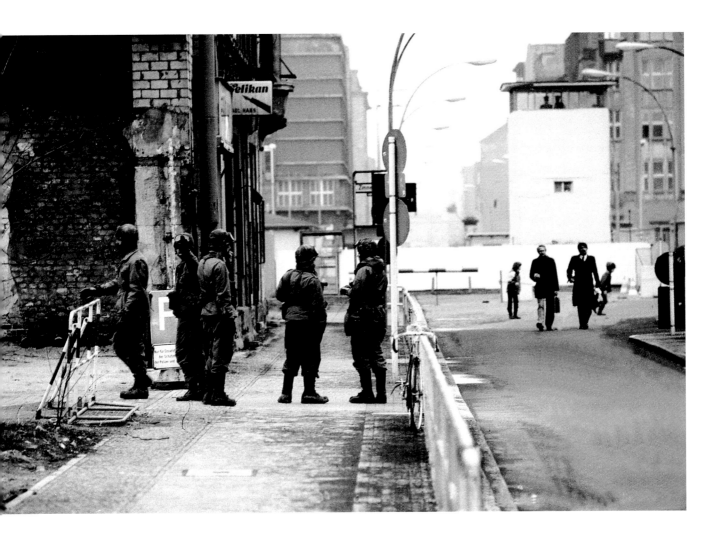

*Die Friedrichstraße am Checkpoint Charlie, 1981*

Neben Brandenburger Tor und Bernauer Straße war der Checkpoint Charlie wohl spätestens seit der Konfrontation sowjetischer und US-amerikanischer Panzer im Oktober 1961 der international bekannteste Ort an der Mauer in der Innenstadt. Checkpoint Charlie war ein Grenzübergang, der Diplomaten, alliiertem Militärpersonal sowie Ausländern vorbehalten war.

*Friedrichstraße at Checkpoint Charlie, 1981*

Aside from the Brandenburg Gate and Bernauer Straße, Checkpoint Charlie was at least since the confrontation of Soviet and American tanks in October 1961 probably the most world famous place on the wall in the city centre. Checkpoint Charlie was a border crossing reserved for diplomats, allied military personnel, and foreigners.

*Die Friedrichstraße an der Kreuzung mit der Zimmer-
straße, 2007*

Das nachgebaute viersprachige US-amerikanische
Sektorengrenzschild sowie die Fotoinstallation und der
Nachbau des ersten Kontrollhäuschens mit US-Flagge
in der Straßenmitte halten zwischen neu entstandenen
Bürohäusern die Erinnerung an den einstigen »Check-
point Charlie« wach.

*Friedrichstraße at the junction with Zimmerstraße,
2007*

The reproduced four-language American sector border
sign as well as the photo installation and the replica of
the first control hut with American flag in the middle
of the street keep the memory of the former "Check-
point Charlie" alive amid newly built office blocks.

61

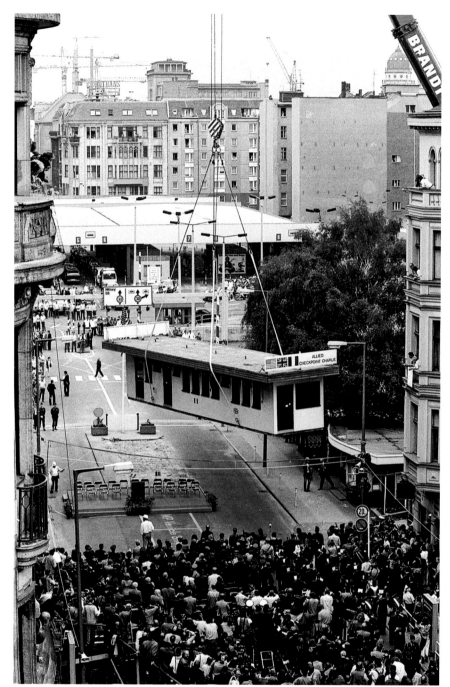

*Der letzte Tag des Kontrollhäus-
chens am Checkpoint Charlie, 1990*

Die bescheidene Baracke der US-Ar-
mee am Grenzübergang Friedrich-
straße, der alliierten Militärangehö-
rigen, Diplomaten und Ausländern
vorbehalten war, wurde im Juni
1990 ins Museum überführt.

*Removing the famous control hut
at Checkpoint Charlie, 1990*

The modest US army control hut
at the crossing point Friedrichstra-
ße, which Was reserved for allied
military personnel, diplomats and
foreigners, was carefully removed
to a museum in June 1990.

*Die Friedrichstraße zwischen Koch-
straße (heute hier Rudi-Dutschke-
Straße) und Krausenstraße, 2007*

*Rund um die Nord-Süd-Achse des
Stadtzentrums, die Friedrichstraße
zwischen Bahnhof Friedrichstraße
und Zimmerstraße setzte nach dem
Mauerfall eine massive Bautätig-
keit ein. Dies ließ das traditionelle
Geschäftszentrum der Stadt wieder
auferstehen.*

*Friedrichstraße between Kochstraße
(here today Rudi-Dutschke-Straße)
and Krausenstraße, 2007*

*After the fall of the Wall building
activity rapidly flourished around the
north-south axis of the city centre
between Friedrichstraße Station
and Zimmerstraße. This heralded a
renaissance of the city's traditional
business centre.*

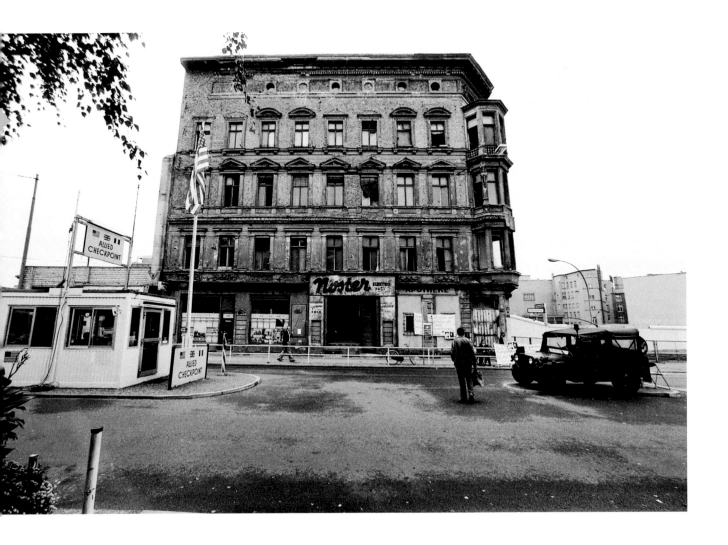

Am Checkpoint Charlie, 1984

Das Foto zeigt eine für die 80er-Jahre typische Szenerie und die Atmosphäre bizarren Alltagslebens an der Mauer; hinter der neu aufgestellten, noch hell leuchtenden »Mauer der vierten Generation« entlang der Zimmerstraße (rechts) kümmerliche Reste einstiger City-Bauten.

At Checkpoint Charlie, 1984

This photograph reflects a typical scene during the eighties and the bizarre atmosphere surrounding the Wall. Behind a bright new section of the "Wall of the fourth generation" along Zimmerstraße (right), derelict remains of old city housing.

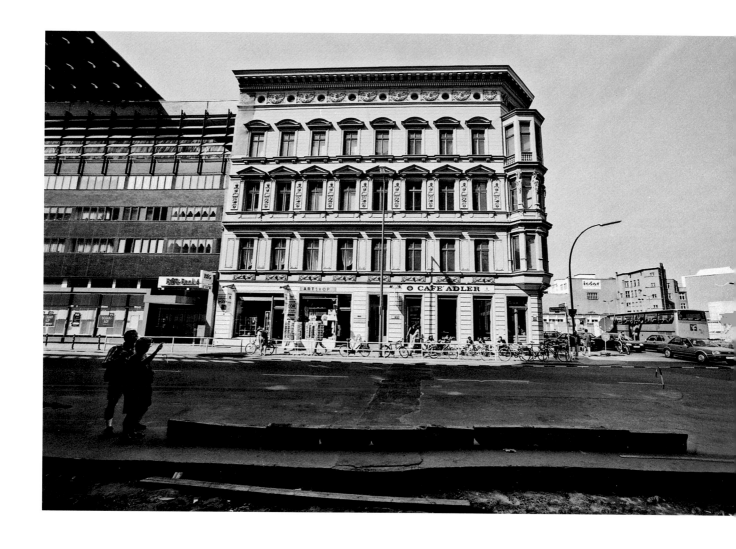

*Das Café Adler an der Kreuzung Friedrichstraße / Zimmerstraße, 1996*

In der Nacht vom 9. auf den 10. November 1989 hatte das CaféAdler, unmittelbar am Checkpoint Charlie gelegen, den stärksten Besucherandrang seiner Geschichte. Jetzt herrscht hier ringsum die Normalität des Baubooms, und das Kontrollhäuschen der Alliierten steht im Museum.

*Café Adler at the junction of Friedrichstrassse and Zimmerstraße, 1996*

Café Adler at Checkpoint Charlie registered a record number of guests during the night of 9 to 10 November 1989. It is now surrounded by the relative normality of the building boom while the small Allied Checkpoint hut has become a museum exhibit.

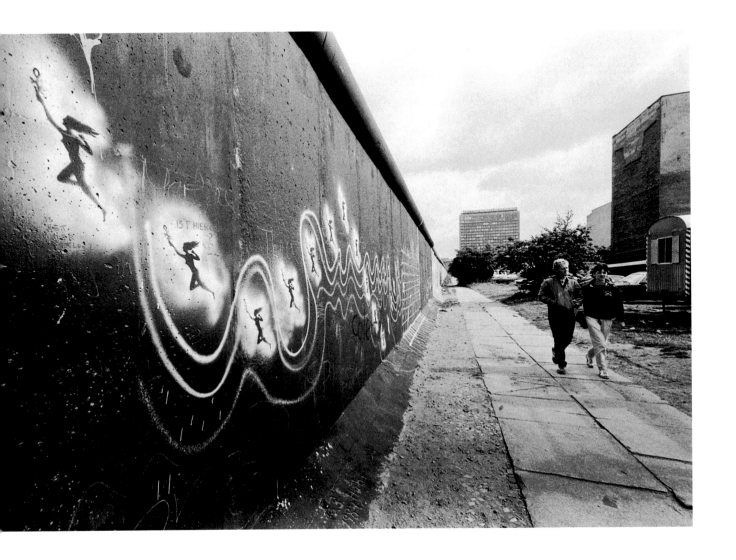

Die Mauer zwischen Friedrichstraße und Springer-Hochhaus, 1985

Die Aufnahme vermittelt einen Eindruck von der »endlosen Geradlinigkeit« des Mauerverlaufs zwischen der Stresemannstraße im Nordwesten Kreuzbergs und der Lindenstraße (in ihrem nördlichen Abschnitt heute Axel-Springer-Straße).

The Wall between Friedrichstraße and the Springer publishing house, 1985

This picture gives an impression of the "incessant straightness" of the Wall along Stresemannstraße in the north-West of Kreuzberg and Lindenstraße (today named Axel-Springer-Straße at its northern section).

Die Zimmerstraße zwischen Friedrich- und Linden-
straße, 2014

Die Neubauten auf beiden Seiten der Zimmerstra-
ße haben die alten Baufluchten wiederhergestellt,
wodurch die Enge der Straße wieder spürbar wird. Die
Leerstandsrate in den neuen Bürogebäuden wird aber
auf absehbare Zeit hoch bleiben.

Zimmerstraße between Friedrichstraße and Linden-
straße, 2014

The new buildings on both sides of Zimmerstraße have
restored the old contours and narrow atmosphere of
this street. But the vacancy rate in the new office build-
ings will remain high for the foreseeable future.

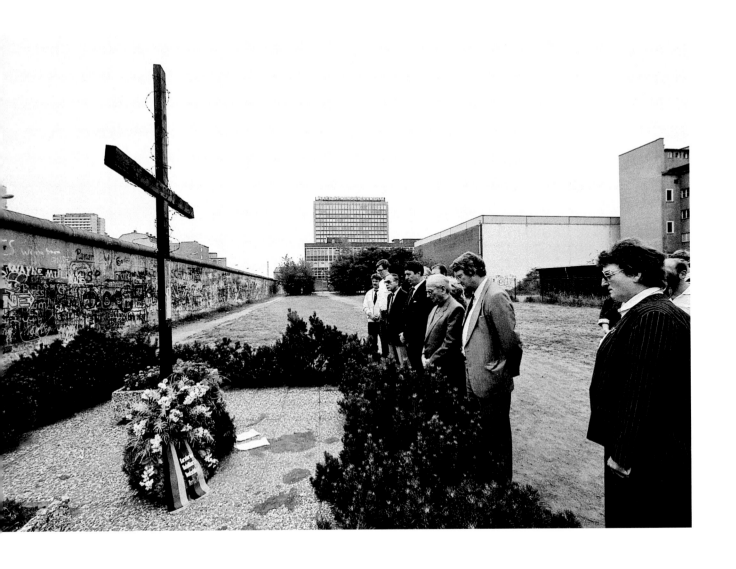

*Trauerfeier an der Peter-Fechter-Gedenkstätte, 1983*

Am 17. August 1962 verblutete der 18-jährige Peter Fechter, von DDR-Grenzposten angeschossen, an der Mauer in der Zimmerstraße. Erst nach 50 Minuten wurde er abtransportiert. Auf der Westseite der Mauer erinnerte seitdem eine schlichte Gedenkstätte mit einem Holzkreuz an die Tat.

*Remembrance ceremony at the Peter Fechter Memorial, 1983*

On 17 August 1962, 18-year-old Peter Fechter bled to death at the Wall after being shot by GDR border guards. He lay bleeding for fifty minutes before being removed. A simple wooden cross was erected as a memorial on the west side of the Wall.

Die Zimmerstraße zwischen Charlotten- und Mark-
grafenstraße, 2002

An die Stelle der Gedenkstätte ist eine Stele zum
Gedächtnis an Peter Fechter getreten. Der auf der
Nordseite der Zimmerstraße neu errichtete Gebäu-
dekomplex (links, Architekt: Aldo Rossi) täuscht mit
seinen gegliederten Fassaden die Kleinteiligkeit der
früheren Bebauung vor.

Zimmerstraße between Charlottenstraße and Mark-
grafenstraße, 2002

Instead of the memorial site, there is now a stele as a
memorial to Peter Fechter. The outer variety of the new
complex on the north side of Zimmerstraße (left; archi-
tect: Aldo Rossi) was designed to create the illusion of
separate houses which once characterised this area.

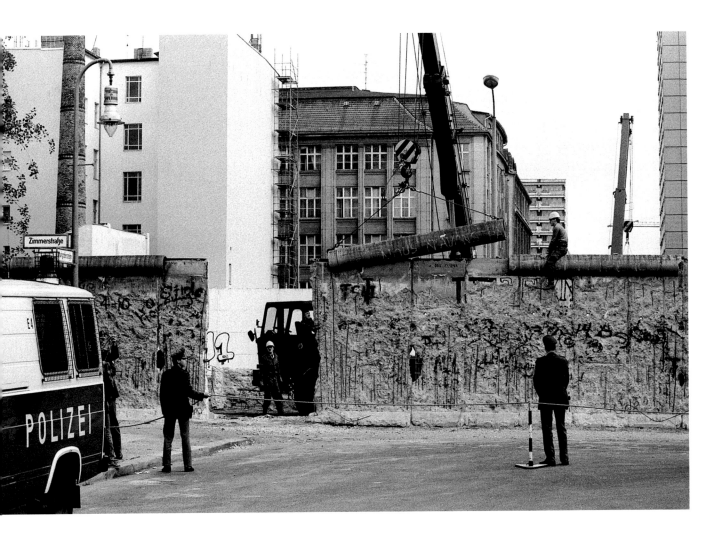

*Abriss der Mauer an der Kreuzung Zimmerstraße / Markgrafenstraße, 1990*

Der größte Teil der innerstädtischen Grenzanlagen wurde noch zu DDR-Zeiten abgetragen, unter der Regie der Grenztruppen selbst. Der Kran entfernt gerade ein Stück der Betonröhre, die als »Mauerkrone« jegliches Festhalten unmöglich machen sollte.

*Tearing down the Wall at the junction of Zimmerstraße and Markgrafenstraße, 1990*

The majority of the inner-city border installations were dismantled by GDR border guards during the last months of the state's existence. The crane is removing a section of concrete pipe, the Wall's "crown", designed to prevent grabbing hold to it.

*Die Kreuzung Zimmerstraße / Markgrafenstraße, 2002*

Die Lücken, die durch Krieg und Nachkriegsabrisse entstanden waren, werden gefüllt. Hier im »Quartier Schützenstraße«, das einen großen rechteckigen Block einnimmt –, und an vielen anderen Stellen der Stadt sieht es fast so aus, als hätte es die Mauer nie gegeben.

*The junction of Zimmerstraße and Markgrafenstraße, 2002*

The gaps caused by the war and postwar demolition are being filled, in this case by the "Quartier Schützenstraße", which occupies a large rectangular block. The city image changes, looking almost as if the Wall had never existed.

71

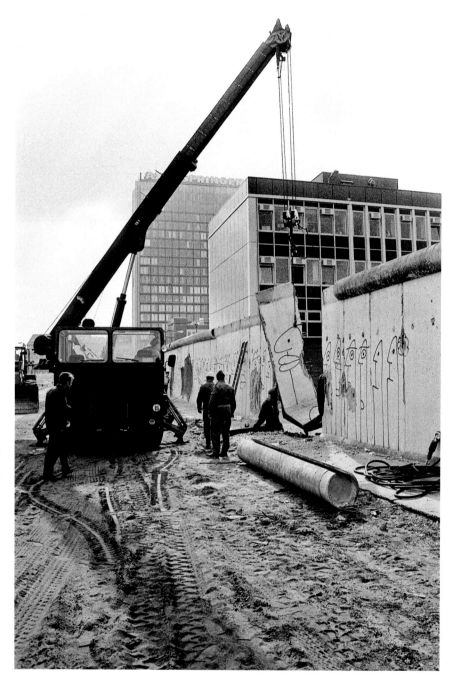

*Abbruch der Mauer an der Zimmer-
Ecke Markgrafenstraße, 1990*

**Als demonstrativen politischen
Akt ließ der Verleger Axel Caesar
Springer zwischen 1961 und 1966
den Neubau seiner Konzernzentrale
unmittelbar an der Mauer errichten.**

*Dismantling the Wall on Zimmer-
straße at the corner of Markgrafen-
straße, 1990*

**In an act of political defiance, the
publisher Axel Caesar Springer had
his new headquarters built right
next to the Wall between 1961
and 1966.**

*Die Zimmerstraße am Springer-Verlagsgebäude, 2007*

*Ein neu angelegter Gehweg verläuft dort, wo einst Mauer und Grenzstreifen direkt an das Grundstück des Axel-Springer-Verlages stießen. Durch Neubauten wurde auch hier die Blockrandbebauung wiederhergestellt.*

*Zimmerstraße at the Springer publishing house, 2007*

*A new pavement has replaced the Wall and border strip beside the Axel Springer publishing house. New buildings were erected to close old gaps and reconstruct traditional city contours.*

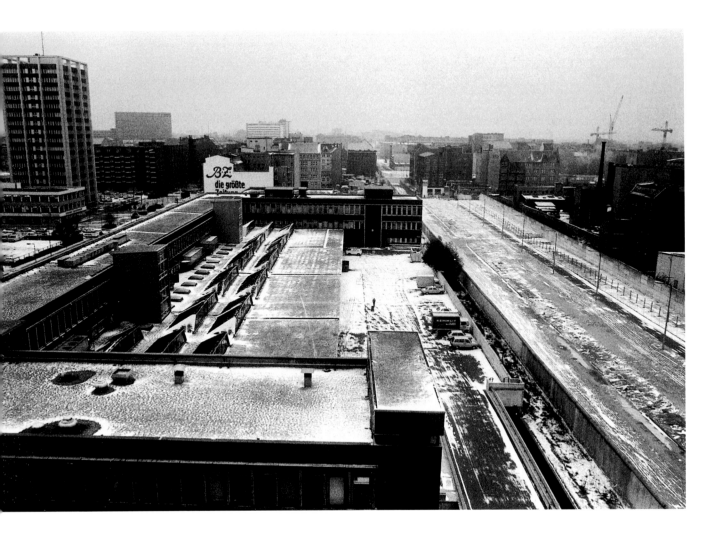

Die Mauer am Verlagshaus Axel Springer, 1984

The Wall beside the Axel Springer publishing house, 1984

Die Gebäude des Axel-Springer-Verlages lagen hart an Mauer und Grenzstreifen auf der Zimmerstraße. Im Hintergrund ist der Grenzübergang Friedrichstraße (»Checkpoint Charlie«) zu erkennen.

The buildings of the Axel Springer publishing house stood directly at Wall and border strip on Zimmerstraße. In the background, the border crossing at Friedrichstraße („Checkpoint Charlie") can be seen.

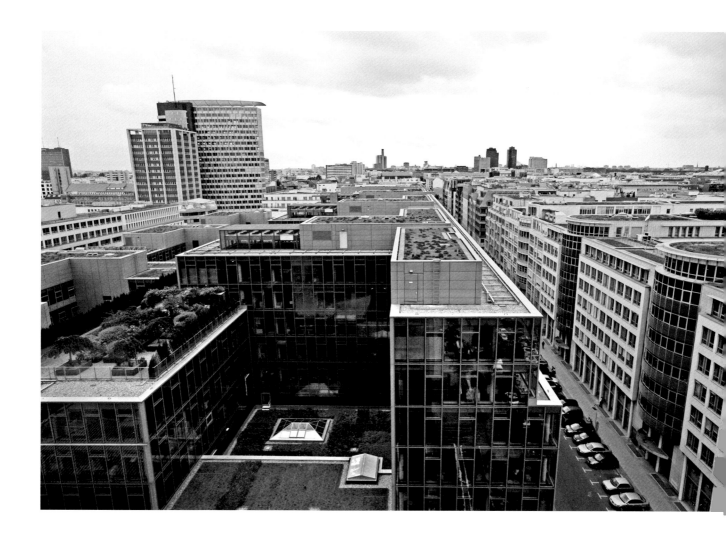

Neubauten beiderseits der Zimmerstraße, 2010

Die Gegend ist kaum wiederzuerkennen: Auf dem Grundstück südlich der Zimmerstraße steht nun die Axel-Springer-Passage (Vordergrund), anstelle von Mauer und Grenzstreifen die Zimmerstraße mit neuen Bürohäusern an der Nordseite (rechts).

New buildings on both sides of Zimmerstraße, 2010

Now the area is hard to recognize: on the site south of Zimmerstraße is now the Axel-Springer-Passage (foreground), instead of Wall and border strip, the Zimmerstraße with new office buildings on its north side (right).

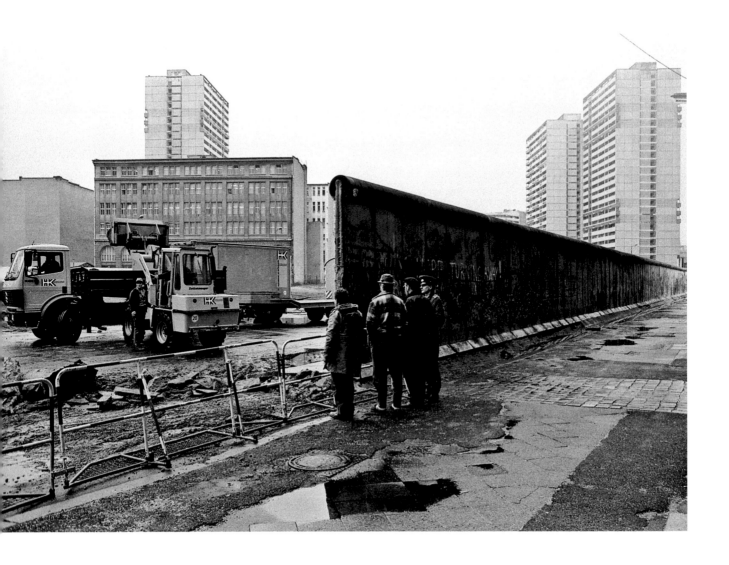

Abbruch der Mauer an der Lindenstraße, 1990

Zu Mauerzeiten war dies das Endstück der Linden-
straße, die seit 1931 weiter Richtung Spittelmarkt führ-
te. Noch im Juni 1962 waren nicht weit von hier unter
einem später abgerissenen Haus mehrere Menschen
durch einen Tunnel in den Westen geflohen.

Dismantling the Wall on Lindenstraße, 1990

In the Wall era this was the last section of Lindenstraße
which led since 1931 further towards Spittelmarkt. In
1962, not far from here, several people escaped to the
West through a tunnel from a building that was later
demolished.

*Die Axel-Springer-Straße von der Ecke Zimmerstraße in Richtung Spittelmarkt, 2014*

Auf dem ehemaligen Grenzstreifen wurde ein massiger Hotel-Neubau errichtet (Bildmitte). Westlich (links) davon steht an der Schützenstraße hinter der hellen Plane ein altes, erhalten gebliebenes Geschäftshaus. Die Wohnhochhäuser an der Leipziger Straße, im Hintergrund, waren einst die Antwort der DDR auf das Springer-Hochhaus.

*Axel-Springer-Straße from the corner of Zimmerstraße towards Spittelmarkt, 2014*

On the former border strip a massive new hotel building was built (in the middle). To the west (left) of it, on Schützenstraße, behind the light-coloured canvas, there is still an old business building. The residential high-rises on Leipziger Straße, in the background, were once the response of the GDR to the Springer tower.

77

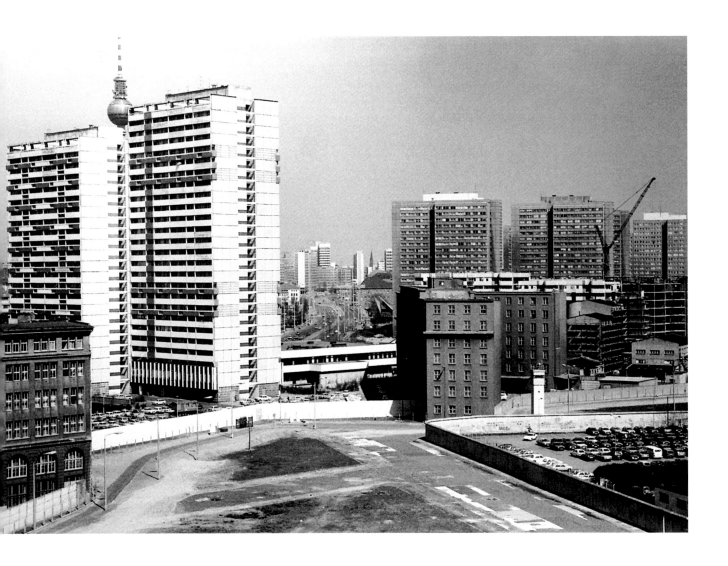

*Die Mauer über die Lindenstraße und entlang der Kommandantenstraße, 1985*

*Der breite Grenzstreifen auf der Reinhold-Huhn-Straße (vorne links, heute wieder Schützenstraße) und der Lindenstraße (vorne rechts, heute hier Axel-Springer-Straße) bis zur Kommandantenstraße (rechts, mit Wachturm). Hinter der Mauer vorne rechts waren Fußgänger politisch im »Westen«, aber geographisch im »Osten«! Die Sichtachse von Spittelmarkt und Gertraudenstraße (Bildmitte) war in Ost-Berlin versperrt durch den zweigeschossigen Flachbau für eine »Exquisit«-Modeboutique.*

*The Wall across Lindenstraße and along Kommandantenstraße, 1985*

*The wide border strip on the Reinhold-Huhn-Straße (front left, today again Schützenstraße) and Lindenstraße (front right, here today Axel-Springer-Straße) to Kommandantenstraße (right, with watchtower). Behind the wall, front right, pedestrians were politically in the "West" but geographically in the "East"! The view from Spittelmarkt and Gertraudenstraße (centre) was blocked in East Berlin by the two-storey building for an "Exquisit" fashion boutique.*

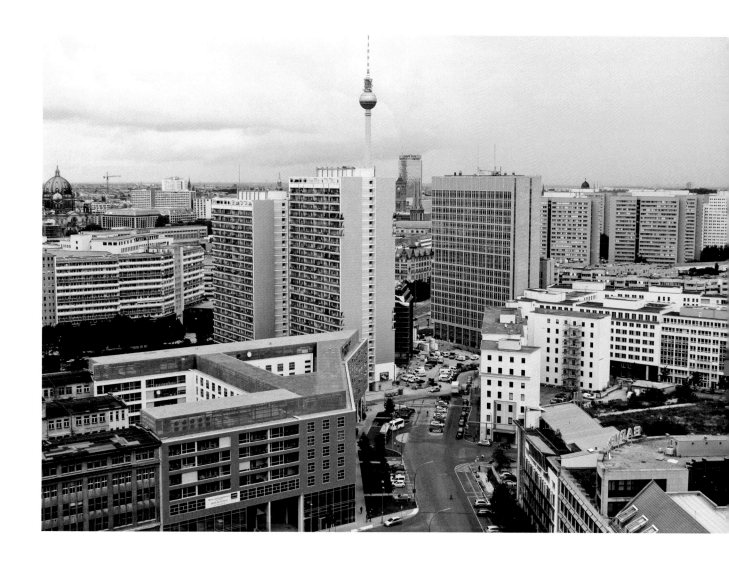

*Blick entlang der Axel-Springer-Straße zum Spittelmarkt, 2010*

Der Grenzstreifen wurde westlich der Axel-Springer-Straße bereits teilweise wieder bebaut, der Flachbau der Modeboutique abgerissen und dort ein Hotel (das teils verdeckte dunkle Haus in der Bildmitte) errichtet. Die Straße wird dort wieder bis zum Spittelmarkt verlängert.

*View along Axel-Springer-Straße to Spittelmarkt, 2010*

The border strip west of the Axel-Springer-Straße is partly covered with buildings again, the low building of the fashion boutique demolished and a hotel (the partly hidden dark house in the middle) built there. The street is to be extended up to Spittelmarkt again.

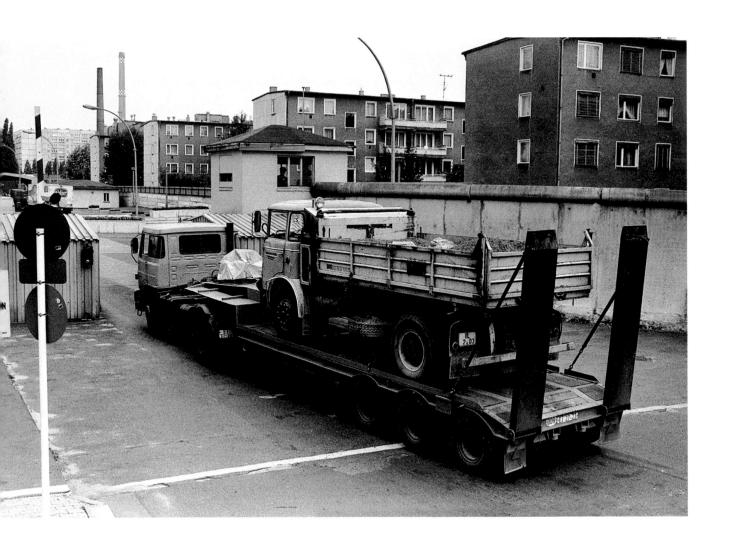

*Der Grenzübergang Heinrich-Heine-Straße, 1986*

Von der Kommandantenstraße an verlief die Mauer generell in Südostrichtung, aber nicht mehr geradlinig, sondern stark gezackt. Die Aufnahme zeigt eine delikate Situation: die Rückführung eines Lastwagens nach Ost-Berlin, mit dem DDR-Bürger erfolgreich die Grenzübergangsstelle Friedrichstraße (»Checkpoint Charlie«) durchbrochen hatten.

*The border crossing point Heinrich-Heine-Straße, 1986*

From Kommandantenstraße the Wall took a south-eastern course, but instead of being straight, it ran in irregular zigzags. The picture shows a delicate situation: a lorry is being returned to East Berlin. Some GDR citizens had used it successfully to break through the border crossing point Friedrichstraße ("Checkpoint Charlie").

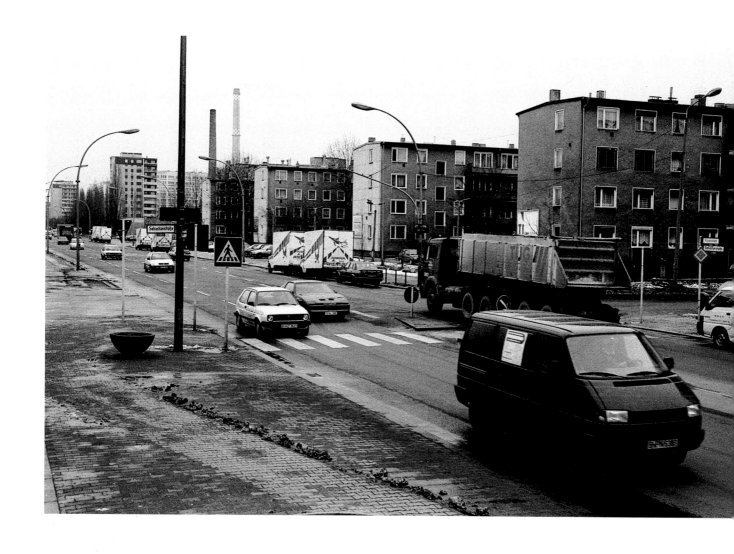

*Blick in die Heinrich-Heine-Straße nach Norden, 1994*

*Looking north along Heinrich-Heine-Straße, 1994*

In Vorkriegszeiten war dies ein belebtes Viertel un-
weit der City. Erst der Fall der Mauer offenbarte die
Nachkriegs-Trostlosigkeit der Gegend. Vorne links
eine Behelfszufahrt, die am westlichen Kontrollpunkt
vorbeiführte, da die Sebastianstraße in voller Breite zu
Ost-Berlin gehörte.

In pre-war days this was a popular quarter close to the
city centre. The fall of the Wall exposed its postwar
desolation. On the left, a provisional access road which
led past the western checkpoint as the whole width of
Sebastianstraße belonged to East Berlin.

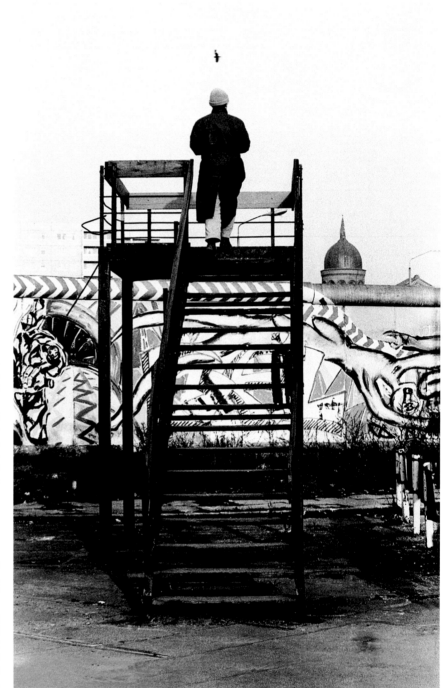

*Blick über die Mauer in der Walde-marstraße auf die St.-Michael-Kirche, 1984*

*Die hölzerne Aussichtsplattform bot den Blick auf die St.-Michael-Kirche. Sie steht in der Hauptachse des 1926–1928 zugeschütteten Luisenstädtischen Kanals. Das Bild zeigt die Stelle, wo die Mauer ihn durchschnitt.*

*The Wall in Waldemarstraße with the dome of the St Michael Church, 1984*

*The wooden platform offered a view of St Michael Church. It stood in the main axis of the Luisenstadt Canal which was filled in between 1926 and 1928. The picture shows where it was severed by the Wall.*

*Blick aus der Luckauer Straße auf Neubauten an der Dresdner Ecke Waldemarstraße, 2014*

*Einst standen in dieser Gegend Handel und Gewerbe in höchster Blüte. Nun schließen Wohnhäuser auf dem ehemaligen Grenzstreifen die Häuserfront wieder.*

*View from Luckauer Straße of new buldings at Dresdner Straße corner of Waldemarstraße, 2014*

*Trade and small industry once flourished in this area. Residential buildings on the former border strip now complete the row of houses again.*

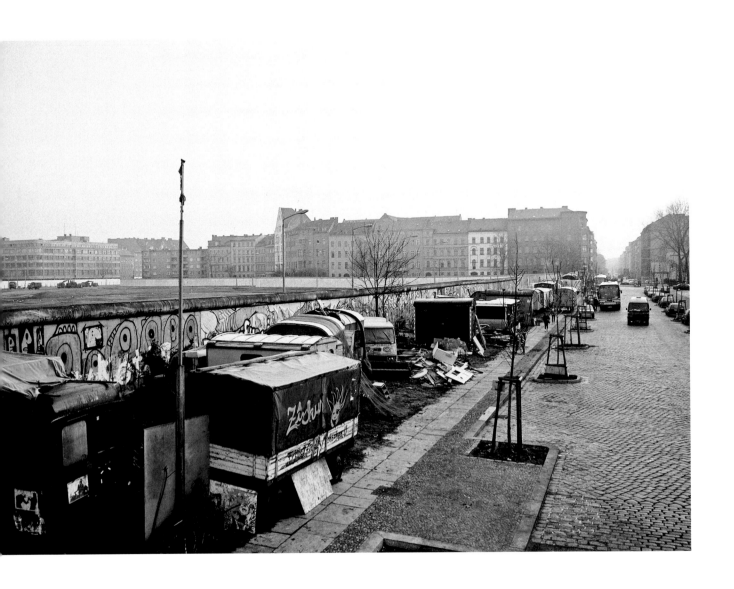

*Die Mauer entlang der Waldemarstraße, 1988*

*Die zu Ost-Berlin gehörende Bebauung nördlich der Waldemarstraße wurde nach dem Mauerbau im Laufe der Jahre vollständig abgerissen. Der Grenzstreifen war hier teils mehrere Hundert Meter breit. Auf dem »Unterbaugebiet« zwischen Grenze und Mauer hatte sich eine Wagenburg angesiedelt. Deren Bewohner bewahrten die Graffiti vor den »Mauerspechten«, so dass diese Mauersegmente nach dem Mauerfall unversehrt geborgen und einige davon mit großem Gewinn versteigert wurden.*

*The Wall along Waldemarstraße, 1988*

*The buildings belonging to East Berlin north of Waldemarstraße were completely demolished during the Wall years. The border strip was sometimes several hundred metres wide here. On the "outer strip" between border line and Wall a trailer village had settled. Its inhabitants preserved the graffiti against the "Wall woodpeckers", so that these wall segments were removed unharmed after the fall of the Wall and some of them were auctioned for huge profits.*

*Blick entlang der Waldemarstraße nach Südosten, 2014*

*Der ehemalige Grenzstreifen wurde in den letzten Jahren wieder vollständig mit Wohnhäusern bebaut.*

*Looking down Waldemarstraße to the south-east, 2014*

*The former border strip was completely built up with residential blocks again in recent years.*

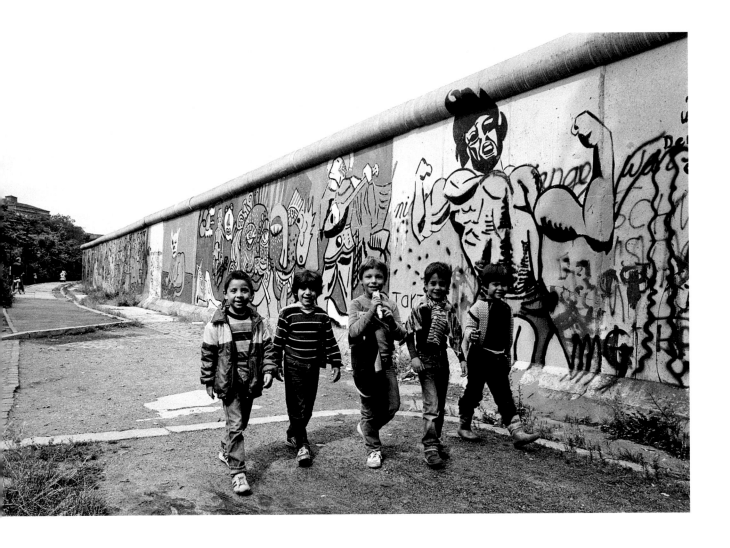

*Mit Graffiti bemalte Mauer am Bethaniendamm, 1984*

Bethanienufer und Engelufer hatten einst den Luisen-
städtischen Kanal gesäumt, nach dessen Zuschüttung
einen Grünzug. Dieser wurde nach dem Mauerbau ein
»maßgeschneiderter« Todesstreifen zwischen Außen-
mauer und nach Ost-Berlin gerichteter Innenmauer.

*The Wall with graffiti on Bethaniendamm, 1984*

Once Bethanienufer and Engelufer formed the banks of
the Luisenstadt Canal, which was filled in and grassed
over. Ironically, it became a "tailor-made" death strip
during the Wall years, flanked by the outer wall, and
the inner wall towards East Berlin.

Bethaniendamm und Engeldamm, 2009

Wie entlang der Zimmerstraße die Friedrichstadt, schnitt die Grenze zwischen den Bezirken Mitte und Kreuzberg – und damit ab 1961 die Mauer – auch am Bethaniendamm einen Stadtteil des alten Berlin, die Luisenstadt, in zwei Teile. Auch hier bleibt auf absehbare Zeit ein innerstädtisches Gefüge lädiert.

Bethaniendamm and Engeldamm, 2009

The Wall followed the district border along Zimmerstraße which cut through the old city quarter of Friedrichstadt, in the same way as the border between Mitte and Kreuzberg along Bethaniendannn split Luisenstadt into two. It will take time for the two parts to grow together again.

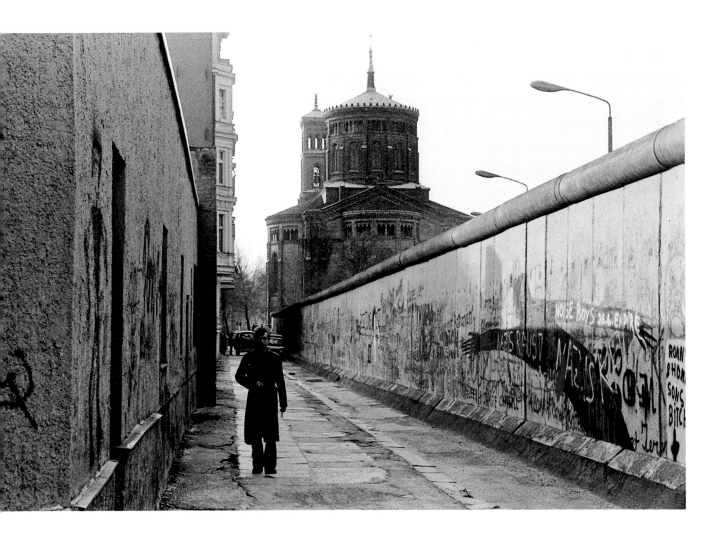

Die Mauer entlang des Bethaniendamms an der St.-Thomas-Kirche, 1983

An der Nordseite des Mariannenplatzes und bis 1990 direkt an der Mauer, erhebt sich die zweitürmige St.-Thomas-Kirche mit ihrer über 50 m hohen Kuppel. Auch diese Aufnahme zeigt, wie sehr die Mauer zum »normalen« Bestandteil des Alltags in West-Berlin geworden war.

The Wall along Bethaniendamm with St Thomas Church, 1983

On the north side of Mariannenplatz and next to the Wall until 1990, St Thomas Church with its more than fifty metres high dome and its two towers rears up. This picture shows just how "normal" the Wall had become in West Berlin's everyday life.

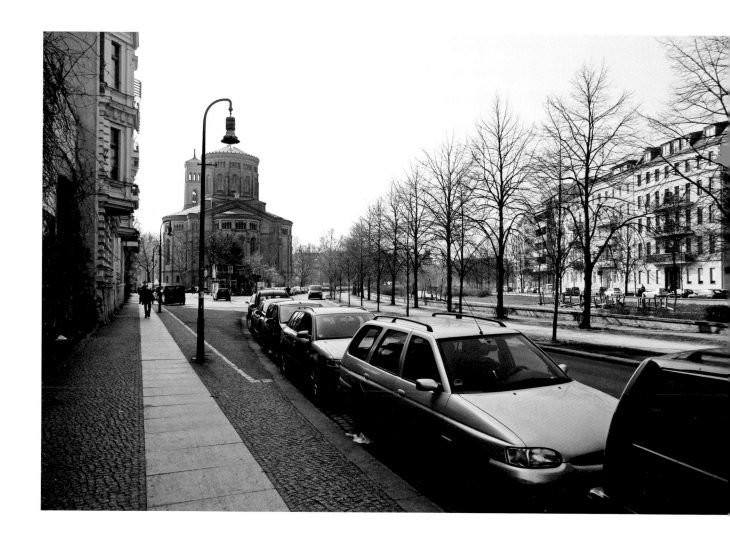

*Bethaniendamm und Engeldamm nördlich der*
*St.-Thomas-Kirche, 1994*

*Die Trennung, die die Mauer zwischen »Ost« und*
*»West«, hier zwischen den Bezirken Mitte und Kreuz-*
*berg erzwang, ist aufgehoben. Dennoch hat man auch*
*Jahre nach der Wiedervereinigung den Eindruck, als*
*habe jemand einen unsichtbaren, aber wirkungsvollen*
*Trennstrich gezogen.*

*Bethaniendamm and Engeldamm north of*
*St Thomas Church, 1994*

*The separation enforced by the Wall between "East"*
*and "West", here between the districts of Mitte and*
*Kreuzberg, is lifted. Even so, years after reunification*
*the impression still lingers as if someone has drawn an*
*invisible but effective dividing line.*

*Die Spree an der Oberbaumbrücke zwischen Friedrichs-hain und Kreuzberg, 1982*

*Vom Gröbenufer (heute May-Ayim-Ufer) geht der Blick über die Spree, die hier in voller Breite zu Ost-Berlin gehörte, zu der im 2. Weltkrieg beschädigten Brücke. Flüchtlinge, die an dieser Stelle schwimmend das Kreuzberger Ufer zu erreichen suchten, wurden von den DDR-Grenztruppen beschossen, einige getötet.*

*The bridge Oberbaumbrücke on the river Spree between Kreuzberg and Friedrichshain, 1982*

*Looking from Gröbenufer (today May-Ayim-Ufer) in Kreuzberg: the river Spree and the war-damaged bridge, Oberbaumbrücke. Here, the whole width of the river belonged to East Berlin. GDR border guards shot at people trying to reach the Kreuzberg side here by swimming. Some were killed in the attempt.*

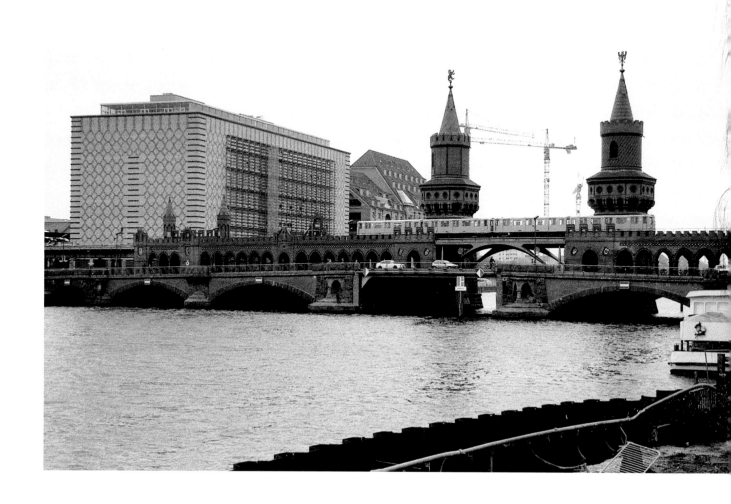

*Die wiederhergestellte Oberbaumbrücke, 2000*

*The restored bridge, Oberbaumbrücke, 2000*

Erst seit ihrer Rekonstruktion erkennt man wieder, dass die Oberbaumbrücke eine Stadtmauer mit Toröffnung und dazugehörigen Türmen darstellt. Tatsächlich trägt sie ihren Namen nach dem Oberbaum, der hier die Spree nachts absperrte, als die Brücke noch die Funktion eines Stadttores auf dem Fluss hatte.

Now that it has been restored the bridge is again recognizable as a city wall with a gate flanked by two towers. The name comes from the "upper boom" which sealed off the Spree at night when the bridge still served as a river gateway to the city.

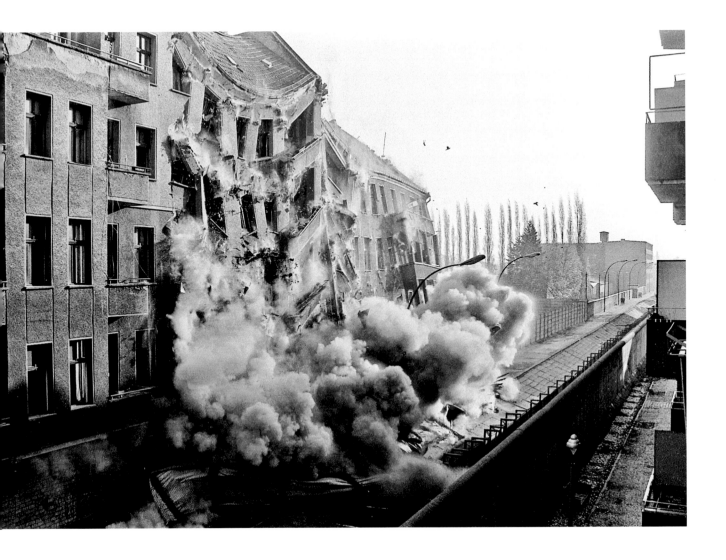

*Sprengung von Wohnhäusern an der Heidelberger Straße Ecke Elsenstraße, 1985*

*An der Heidelberger Straße Ecke Elsenstraße gab es immer wieder dramatische Fluchtaktionen durch Tunnel, mit Lastwagen usw. Seit 1963 wurden in dieser Gegend immer wieder Wohnhäuser gesprengt, um bessere ‹bewachungsmöglichkeiten im Grenzstreifen zu schaffen.*

*Blasting of a block of flats on Heidelberger Straße corner of Elsenstraße, 1985*

*Heidelberger Straße at the corner of Elsenstraße was the scene of many dramatic escape attempts, by tunnel, lorry etc. Since 1963 houses were systematically demolished over the years to ensure better surveillance along the border.*

*An der Heidelberger Straße Ecke Elsenstraße, 1994*

Von der Bebauung an Heidelberger Straße und Elsen-
straße ist vor dem Werk für Signal- und Sicherungs-
technik (Bildmitte) nichts mehr übriggeblieben. Die
Stadtbrache wird nun von einem Parkplatz einge-
nommen.

*At Heidelberger Straße corner of Elsenstraße, 1994*

Here, all the houses along Heidelberger Straße and
Elsenstraße have completely vanished exposing the fac-
tory for signal and safety systems (centre). This urban
wasteland is now being used as a car park.

93

*Die Mauer an der Treptower Straße in Neukölln, 1982*

*Wo die Heidelberger Straße, von Nordwesten her kommend, in die Treptower Straße einmündete, knickte die Bezirksgrenze zwischen Neukölln und Treptow nach Nordosten ab und verlief entlang der Treptower Straße bis zu deren Ende. Dementsprechend verlief auch die Mauer.*

*The Wall on Treptower Straße in the district of Neukölln, 1982*

*Coming from the north-West, Heidelberger Straße joined Treptower Straße in a bend. This also marked the district border between Neukölln and Treptow which turned off north-east following Treptower Straße to the end. The Wall dutifully followed suit.*

*Die Treptower Straße an der Einmündung der Heidelberger Straße, 1994*

*Die Treptower Seite der Heidelberger Straße und die Treptower Straße könnten nach Jahrzehnten von Teilung, Abriss und Trostlosigkeit ein wenig Regeneration durch Neubauten vertragen.*

*Treptower Straße at the corner of Heidelberger Straße, 1994*

*The side of Heidelberger Straße belonging to Treptow district and Treptower Straße are in need of redevelopment after decades of division, destruction and desolation due to the border strip.*

95

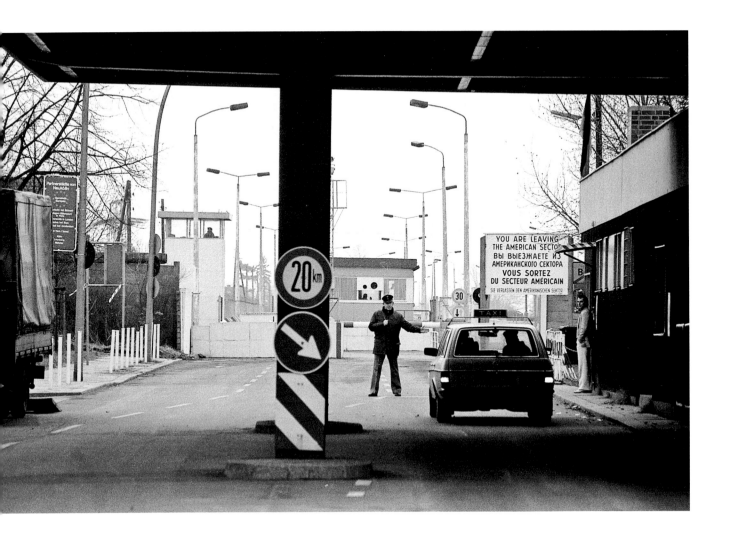

*Die Grenzkontrollstelle Waltersdorfer Chaussee, 1984*

*Der Grenzübergang, auf West-Berliner Seite Abschluss eines vom Hermannplatz her den Bezirk Neukölln durchquerenden Straßenzuges, war im Juni 1963 für Benutzer des Flughafens Schönefeld eingerichtet worden; ein Flugticket berechtigte hier zur »Einreise in die DDR«.*

*The border checkpoint Waltersdorfer Chaussee, 1984*

*Approaching from the west, this border crossing stood at the end of a road leading from Hermannplatz through the district of Neukölln. It was opened in June 1963 for travellers using Schönefeld Airport; an air ticket entitled them to "entry into the GDR".*

*Die Waltersdorfer Chaussee an der Grenze Berlins zu
Brandenburg, 1995*

*Ohne Zwangsaufenthalt durch Grenzkontrollen führt
die Chaussee jetzt zum ab 1946 aufgebauten Flughafen
Schönefeld, der einen Teil des Passagieraufkommens
von ganz Berlin trägt, solange es keinen modernen
Großflughafen für Berlin gibt.*

*Waltersdorfer Chaussee at the border between Berlin
and Brandenburg, 1995*

*No more delays with border controls on Waltersdorfer
Chaussee. There is now free access to Schönefeld Air-
port which was built from 1946 on and shares Berlin's
air traffic until the city opens a new international
airport.*

Die Grenze an der Waßmannsdorfer Chaussee, 1988

The border on Waßmannsdorfer Chaussee, 1988

Die Waltersdorfer wie auch die Waßmannsdorfer Chaussee waren jeweils nach einem märkischen Dorf wenige Kilometer südlich Berlins benannt, zu dem die Straße vom Berliner Stadtrand aus hinführte. Zu Mauerzeiten diente das Grenzgebiet als kümmerliches Ersatz-Ausflugsziel.

Waltersdorfer Chaussee and Waßmannsdorfer Chaussee were both named after small villages, slightly south of Berlin, to which they led from the outskirts. In the Wall era, the border area served as a wimpy substitute destination for outings.

*Die Waßmannsdorfer Chaussee am südlichen Stadt-
rand Berlins, 1994*

*Waßmannsdorfer Chaussee on the southern edge of
Berlin, 1994*

*Ein Bild spätwinterlicher Idylle in Rudow, am südlichen
Rand des wiedervereinigten Berlin. Die Waßmannsdor-
fer Chaussee führt wieder hinaus nach Waßmannsdorf,
Landkreis Dahme-Spreewald. Besondere Kennzeichen:
Rieselfelder und Nähe zum Autobahnzubringer B 96a.*

*A late winter idyll in Rudow on the southern edge of
reunited Berlin. Waßmannsdorfer Chaussee again leads
to Waßmannsdorf in the rural county of Dahme-Spree-
wald. Main features: sewage farms and the B 96a
motorway access route.*

99

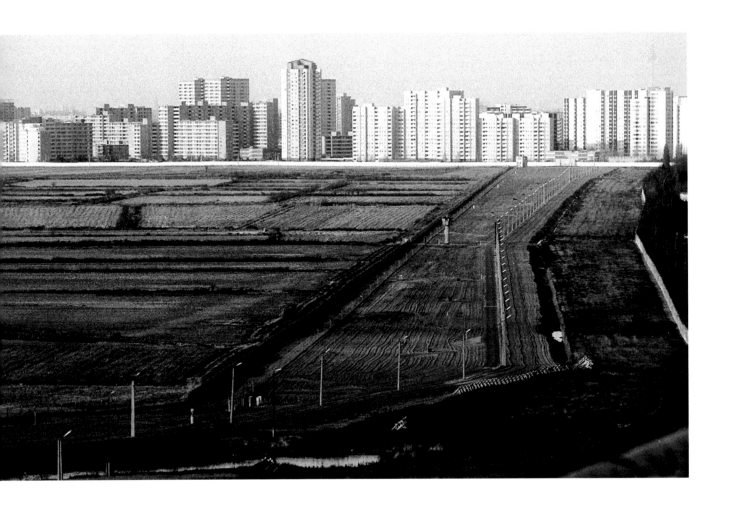

Grenzanlagen und Gropiusstadt, 1986

Die Gropiusstadt wurde wie andere West-Berliner Großwohnsiedlungen in den 1960er und 1970er Jahren nahe an der DDR-Grenze errichtet. Die Konfrontation zwischen Stadtrandsiedlung und Grenzstreifen, wie sie sich durch die Abriegelung West-Berlins seit August 1961 hier aufdrängte, ergab sich unbeabsichtigt.

Border installations and Gropiusstadt, 1986

Gropiusstadt was one of several West Berlin major residential developments built in the 1960s and 1970s close to the GDR border. Confrontation between such satellite developments and the border strip after the sealing-off of West Berlin in August 1961 was unintentional.

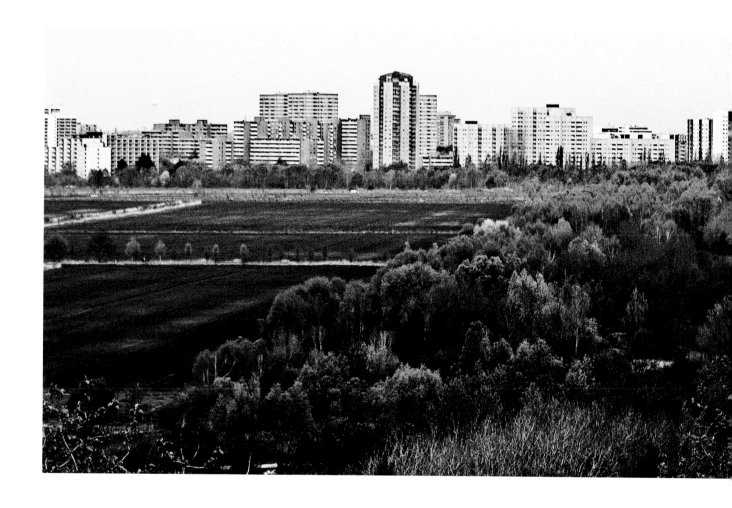

*Vorstadtgrün und Gropiusstadt, 2014*

*Der unvermittelte ‹bergang von Ackerflächen zu
»Punkthäusern in Zeilenbauweise« an dieser Stelle wird
nun durch die Bäume auf dem ehemaligen Grenzstrei-
fen gemildert. Das schwierige städtebauliche Erbe
bleibt. Die Wohnhochhaus-Silhouette der Gropiusstadt
erinnert jedenfalls nicht an Manhattan!*

*Greenery and Gropiusstadt, 2014*

*This sharp contrast between farmland and "bar-code
buildings" here is now mitigated by the trees on the
former border strip. The difficult urban architectural
heritage remains. The silhouette of the high-rise blocks
certainly bears no resemblance to the Manhattan
skyline!*

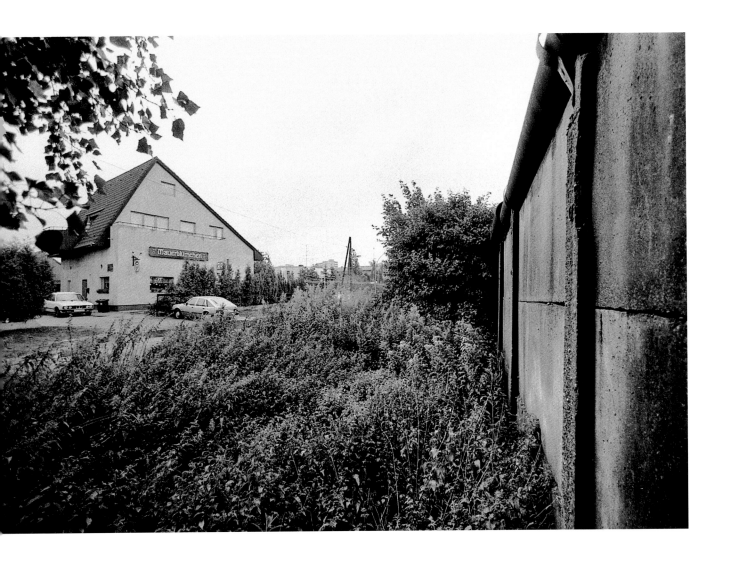

*Die Gaststätte »Mauerblümchen« am Südrand von Buckow, 1986*

In Buckow, wo etwa in der Mitte des West-Berliner Südens die gezackte Grenze weit nach Norden vorsprang, wurde nahe der Mauer Ende der 1970er Jahre eine Diskothek zur Gaststätte umgebaut. Zweimal, 1983 und 1986, gelang DDR-Grenzern die Flucht in das Haus.

*The "Wallflower" restaurant on the southern edge of Buckow, 1986*

Close to the Wall in Buckow, in the middle of West Berlin's southern border which jutted to the north: this is where a discotheque was turned into a restaurant at the end of the 1970s. In 1983 and 1986 GDR border guards made two successful escapes to this house.

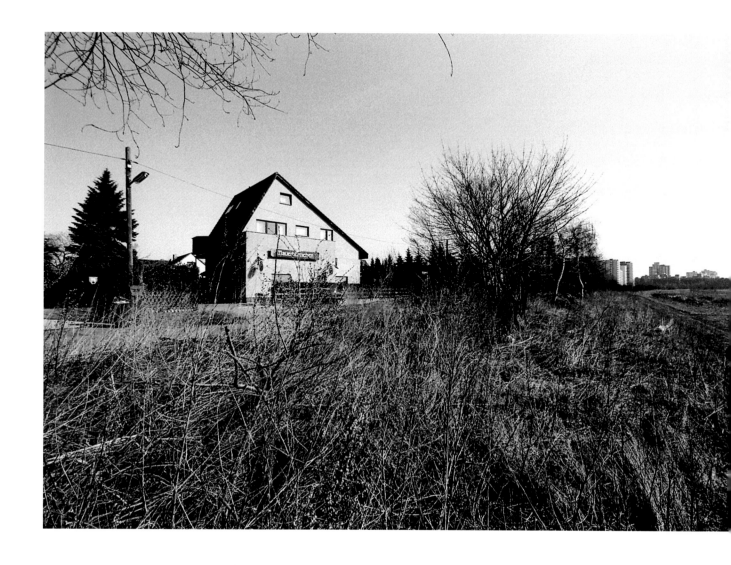

*Die Gaststätte »Mauerblümchen« am Südrand von Buckow, 1994*

*Die Mauer ist verschwunden, das »Mauerblümchen« ist geblieben. Aber wie das so geht im Leben: Seine wirtschaftliche Lage, so versichert der Gastwirt glaubwürdig, habe sich seit dem Wegfall der Grenze und dem Ende des »Mauertourismus« verschlechtert.*

*The "Wallflower" restaurant on the southern edge of Buckow, 1994*

*The Wall has gone but the "Wallflower" pub remained. Life goes on, but the landlord says the economic situation has deteriorated since the border disappeared and the "Wall tourists" stopped coming.*

Mauerbau kurz vor Mauerfall, bei Marienfelde,
April 1989

DDR-Grenzsoldaten ersetzen auf Gebiet der damaligen
Gemeinde Osdorf mit schwerem Gerät den Streckme-
tallzaun durch eine Stahlbetonmauer, selbstverständ-
lich erst, nachdem sie einen »Bauzaun« zwischen dem
alten Zaun und der Grenze errichtet haben.

Construction of the Wall shortly before its fall, outside
Marienfelde, April 1989

GDR border guards using heavy equipment to replace
the expanded metal fence by a ferroconcrete wall on
territory of the then municipality of Osdorf, of course
not before having erected a "construction fence"
between the old fence and the boundary.

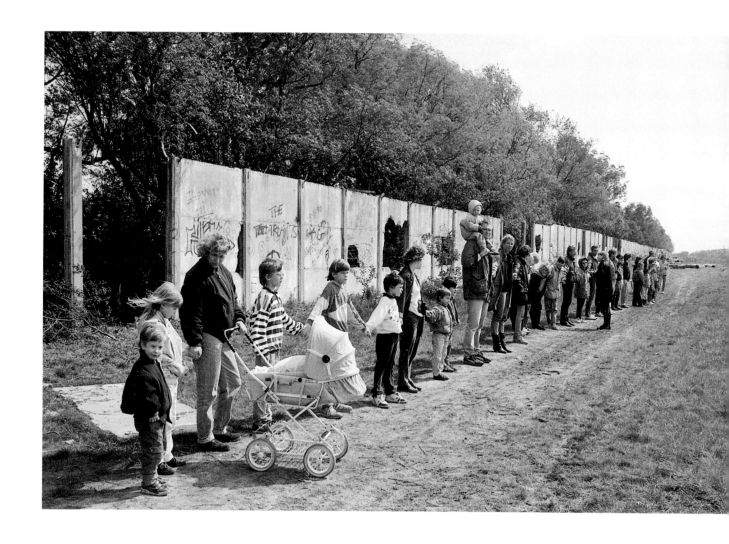

*Maueropfer nach Mauerfall, bei Marienfelde, Mai 1991*

Anwohner haben auf dem ehemaligen Grenzstreifen
von Osdorf eine Menschenkette gebildet im Gedenken
an einen Jungen, der von einem umstürzenden Mauer-
stück erschlagen wurde. Ein letzes, spätes Opfer einer
unmenschlichen Grenze.

*Victim of the Wall after its fall, outside Marienfelde,
May 1991*

Local residents have formed a human chain on the for-
mer border strip of Osdorf in memory of a boy who was
killed by a falling piece of the Wall. A last, late victim of
an inhumane border.

*Die Autobahn bei Dreilinden, 1984*

*Wenige Hundert Meter trennten die Grenzlinie von der legendären Grenzübergangsstelle Drewitz mit ihrer mehrspurigen Abfertigung, den Kontrollhäuschen, den »Dokumenten-Förderbändern« und den Fragen der DDR-Grenzer nach »Waffen, Sprengstoff, Munition, Funkgeräte?«.*

*The motorway near Dreilinden, 1984*

*It was only a few hundred metres from the boundary to the legendary border crossing point Drewitz with its multi-lane processing, control booths, "document conveyor belts" and GDR border guards asking: "Weapons, explosives, ammunition, radios?".*

*Die Autobahn bei Dreilinden, 1994*

Bald wird auch an dieser Stelle die Autobahn von und nach Berlin dreispurig ausgebaut werden, weil der Verkehr sprunghaft angestiegen ist, vor allem auf der Autobahn nach Hannover über Helmstedt – auch früher schon die am stärksten belastete der nach Berlin führenden Strecken.

*The motorway near Dreilinden, 1994*

This section of motorway will soon be widened to three lanes because traffic to and from Berlin has increased so much, especially on the motorway to Hannover via Helmstedt. Already in the Wall era this route to Berlin always had the heaviest traffic.

Blick durch Mauerreste auf das sowjetische Ehrenmal bei Drewitz, 1990

Dieser historische T-34-Panzer der Roten Armee wurde nach etlichen Attacken aufgebrachter West-Berliner in den 1950er Jahren von seinem ursprünglichen Standort an der Potsdamer Chaussee in Zehlendorf auf diesen Sockel am Rand der Autobahn nahe Drewitz versetzt.

The Soviet memorial seen through the shattered Wall near Drewitz, 1990

This historical T-34 Red Army tank was moved onto this pedestal on the side of the motorway near Drewitz from its original site on Potsdamer Chaussee in Zehlendorf after angry West Berliners attacked it several times during the 1950s.

*Das ehemalige sowjetische Ehrenmal bei Drewitz, 1994*

Nach 1990 verschwand der Panzer vom Ehrenmal beim Abzug der sowjetischen Truppen aus Deutschland. 1992 hievte der West-Berliner Aktionskünstler Eckhart Haisch auf den leeren Sockel eine rosa angestrichene alte sowjetische Schneefräse, aus Protest gegen die sinnlose Zerstörung von Denkmälern.

*The former Soviet memorial near Drewitz, 1994*

After 1990 the memorial tank disappeared during the withdrawal of Soviet troops from Germany. In 1992, the West Berlin conceptual artist Eckhart Haisch hoisted a pink-painted old Soviet snowblower onto the empty pedestal in protest against the senseless destruction of memorials.

109

*Autounfall an der Mauer in Wannsee, 1986*

An einigen Stellen, wie etwa an der Ecke Bernauer
Straße/Gartenstraße nutzten Selbstmörder die Mauer,
um sich mit dem Auto das Leben zu nehmen. Nicht
ganz so dramatische, aber auch gefährliche Situation
an der Königstraße in Wannsee kurz vor der Glienicker
Brücke: ein Glatteisunfall.

*Car accident at the Wall in Wannsee, 1986*

In certain places, such as the corner of Bernauer Straße
and Gartenstraße, people used the Wall for suicide by
crashing their car. An also dangerous but less dramatic
incident caused by black ice on Königstraße in Wann-
see, approaching Glienicke Bridge.

*An der Königstraße in Wannsee, kurz vor der Glienicker Brücke, 1994*

*Zurück zur Normalität. Seitdem die Mauer verschwunden ist, ahnt kaum jemand mehr, dass links ein Zipfel von Potsdam, Klein Glienicke, sich zwischen Schloss Glienicke und Böttcherberg in die Südwest-Ecke Berlins hineinzwängt.*

*On Königstraße in Wannsee, approaching Glienicke Bridge, 1994*

*Back to normality. Since the Wall disappeared, hardly anyone is aware that on the left a small section of Potsdam, Klein Glienicke, juts into the south-west corner of Berlin, between Glienicke Palace and Böttcherberg.*

111

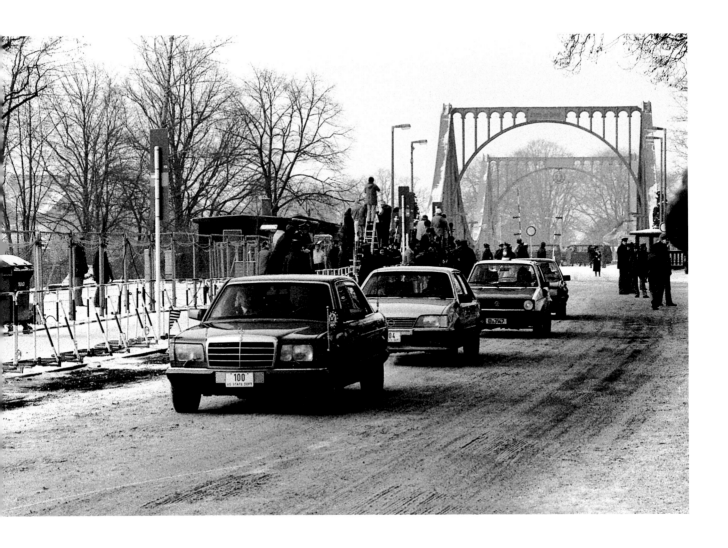

*Gefangenenaustausch auf der »Brücke der Einheit«, 1986*

*Die 1949 in »Brücke der Einheit« umbenannte Glienicker Brücke wurde seit 1962 zum Schauplatz aufsehenerregender Gefangenenaustausche zwischen den Großmächten. Das Foto zeigt die Freilassung des sowjetischen Dissidenten Anatoli Schtscharanski im Austausch gegen östliche Agenten im Februar 1986. Der bekannte Gefangene verlässt den Ort des Geschehens in der gepanzerten Limousine des US-Botschafters Richard Burt.*

*Exchanging prisoners on the "Bridge of Unity", 1986*

*Glienicke Bridge was renamed "Bridge of Unity" in 1949. Since 1962 it was the scene of famous exchanges of prisoners between the major powers. This picture shows the exchange of the Soviet dissident Anatoly Shcharansky for eastern agents in February 1986. The renowned prisoner leaves the site of the exchange in the amoured limousine of US ambassador Richard Burt.*

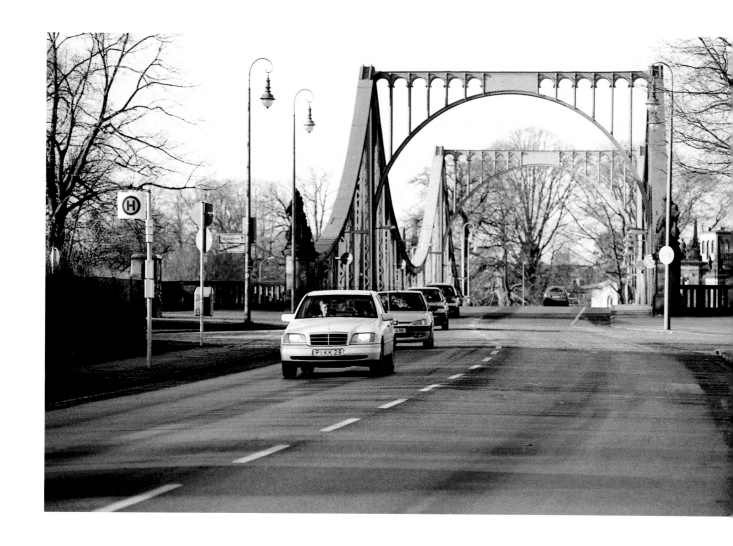

*Blick über Glienicker Brücke von Berlin aus, 1998*

*Looking over Glienicke Bridge from Berlin, 1998*

»Um 18 Uhr ist der Grenzübergang Glienicker Brücke geöffnet worden«, lautete eine Meldung vom Abend des 10. November 1989. Als erster zusätzlicher Grenzübergang auch für Autos freigegeben, wurde die Brücke wieder Teil der wichtigen Verkehrsverbindung zwischen Berlin und Potsdam. Zu Mauerzeiten ausschließlich alliiertem Militär vorbehalten, wurde die Brücke auch bekannt durch der Roman  Der Spion der aus der Kälte kam« des weltberühmten Schriftstellers John le Carré.

On the evening of 10 November 1989 the news broke: "The border crossing at Glienicke Bridge was opened at 6 p.m.". It was the first new border crossing point opened also for cars. The bridge again became a major link between Berlin and Potsdam. Being reserved during the Wall era for allied military only, the bridge became also popular through the novel "The Spy Who Came In From The Cold" by the world-renowned writer John le Carré.

Die Dorfkirche von Staaken mit Wachturm und
Mauer, 1982

The village church at Staaken with watchtower and
Wall, 1982

Der Alliierte Kontrollrat stellte am 30. August 1945 den
westlichen Teil des alten Dorfs Staaken unter sowje-
tische Befehlsgewalt – im Austausch gegen eine Fläche
zum Ausbau des Flugplatzes Gatow. Daher teilte seit
1961 die Mauer das Dorf, mit der Dorfkirche in der DDR.

On 30 August 1945 the Allied Control Council placed
the western part of the old village of Staaken under
Soviet control in exchange for an area to extend Gatow
Airfield. In 1961 the Wall cut the village in two, with the
church inside the GDR.

*Die Dorfkirche von Staaken, 1994*

Die Dorfkirche wurde zwischen 1436 und 1440 erbaut. Das ursprünglich nicht verputzte Gebäude ist aus unbearbeiteten Feldsteinen gemauert. Der Westturm wurde 1712 aus Ziegeln errichtet. Da die nahe gelegene Heerstraße den Fernverkehr abzieht, scheint seit 1990 die alte märkische Idylle wiederhergestellt.

*The village church at Staaken, 1994*

The village church was built between 1436 and 1440. The originally unplastered building is made of unworked field stones. The western tower was built of brick in 1712. In 1990 the old village idyll returned, away from all the long-distance traffic which travels along nearby Heerstraße.

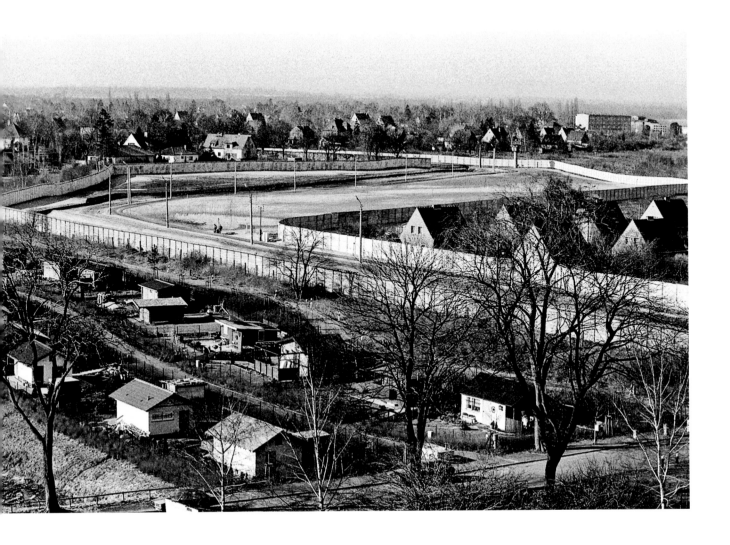

Der Grenzstreifen zwischen Spandau und
Falkensee, 1982

Die Aufnahme von einem hohen Standpunkt über die
Falkenseer Chaussee hinweg lässt erkennen, welche
Schwierigkeiten die DDR hatte, die »modernen« Grenz-
anlagen mit ihrer möglichst tiefen Staffelung dem Ver-
lauf der Grenze an den Stellen anzupassen, wo vor der
Abriegelung West-Berlins locker bebaute Siedlungen ins
Umland übergingen.

The border strip between Spandau and
Falkensee, 1982

The picture, shot from an elevated position across Fal-
kenseer Chaussee, shows the problems facing the GDR
to adapt the "modern" border installations with their
deepest possible structure to the course of the border,
where loose-knit settlements often tended to ignore
the city boundary before West Berlin was sealed off by
the Wall in 1961.

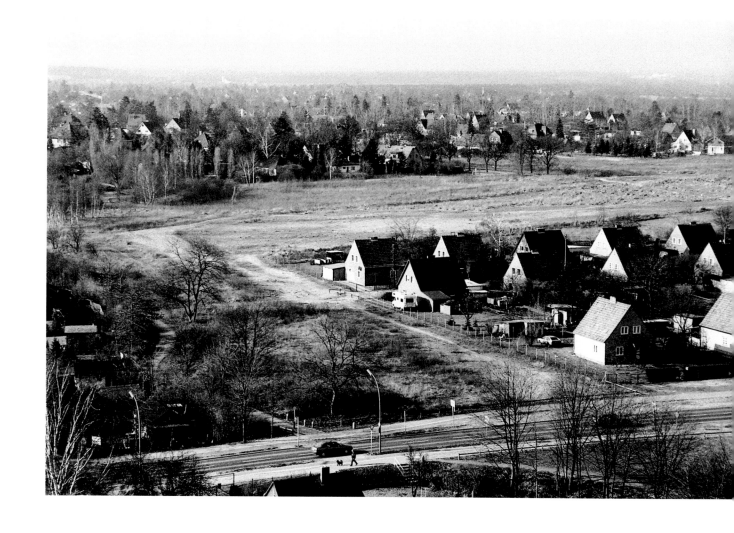

Am westlichen Stadtrand Berlins bei Falkensee, 1994

Unschwer zu erkennen: die Brache, die der einstige Grenzstreifen zwischen den einzelnen Siedlungen hinterlassen hat. In ein paar Jahren wird vermutlich diese »Narbe« entlang der Stadtgrenze Berlins nur noch an wenigen Stellen wahrnehmbar sein.

The western edge of Berlin near Falkensee, 1994

Still visible: the wasteland created between settlements by the border strip. In a few years these "scars" along Berlin's border will presumably have healed over almost everywhere.

*Die nördliche Zubringer-Autobahn im Bau in der Stolper Heide, 1982*

Blick auf die fortgeschrittenen Bauarbeiten an der späteren A111 nördlich der Stadtgrenze in der Stolper Heide. Dieser Zubringer verbindet West-Berlin mit dem Berliner Ring (heute A10) und der Transit-Autobahn nach Hamburg (heute A24). Die Grenzanlagen beiderseits der neuen Autobahn wurden bereits vorher fertiggestellt.

*The northern feeder motorway under construction in the Stolper Heide, 1982*

View of the advanced construction work on the later A111 north of the city boundary in the Stolper Heide. This feeder connects West Berlin to the Berlin Ring (today A10) and the transit motorway to Hamburg (today A24). The border installations on both sides of the new motorway have been completed previously.

*Die Autobahn A111 an der Stadtgrenze von Berlin zu Brandenburg, 2014*

*Diese Zubringer-Autobahn wurde im November 1982 eröffnet. Wald und Gebüsch reichen nun bis an den Straßenrand.*

*The A111 motorway at the border of Berlin with Brandenburg, 2014*

*This feeder motorway was opened in November 1982. Forest and bushes range up to the roadside now.*

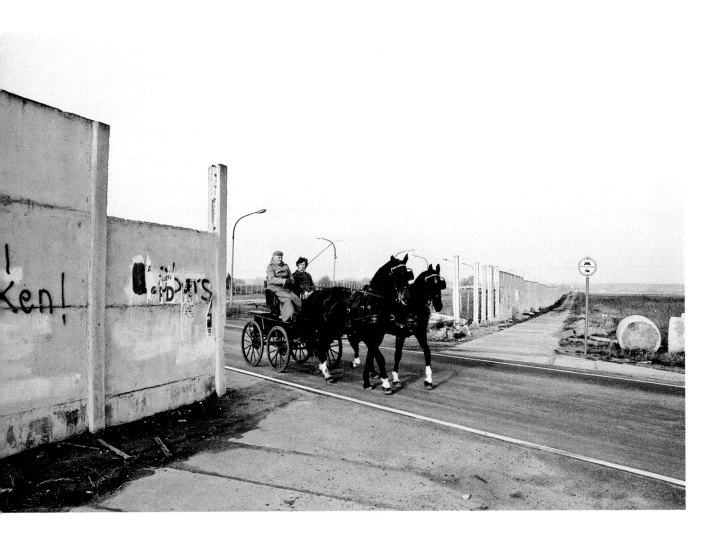

*Die Mauer zwischen Reinickendorf und Pankow, 1990*

*Das Dorf Lübars im Nordosten des (West-)Bezirks Reinickendorf gehörte zu den Orten, in denen man zu Mauerzeiten mehr als einen Hauch märkischer Idylle spüren konnte. Das machte Lübars samt Umgebung zum beliebten Ausflugsziel. Die Aufnahme zeigt die Mauer östlich von Lübars.*

*The Wall between Reinickendorf and Pankow, 1990*

*The village of Lübars in the north-east of the (Western) district of Reinickendorf had much idyllic rural charm during the Wall era. Lübars and its surroundings were popular leisure destinations. The picture shows the Wall to the east of Lübars.*

*Die Grenze zwischen den Bezirken Reinickendorf und Pankow, 1994*

*Wer nicht weiß, dass diese Stelle als Grenze zwischen dem Bezirk Pankow (sowjetischer Sektor) und dem Bezirk Reinickendorf (französischer Sektor) 1945 völkerrechtlich zur Demarkationslinie wurde, sieht ihr heute nicht mehr an, dass diesseits und jenseits der Grenze zwei Welten lagen.*

*The border between the districts of Reinickendorf and Pankow, 1994*

*Few people know that the border between Pankow (Soviet sector) and Reinickendorf (French sector) was declared a demarcation line in international law in 1945. Today no trace is left of the two divided worlds that once existed here.*

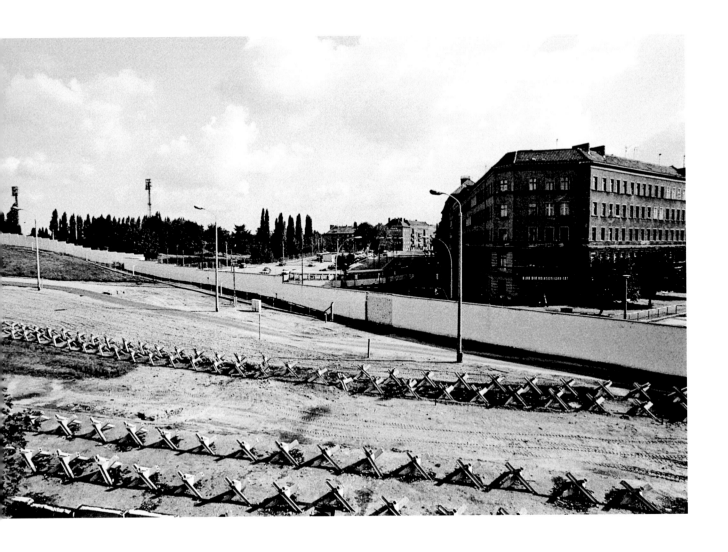

Der Grenzstreifen an der Eberswalder Straße / Bernauer Straße, 1980

Der Blick geht aus dem West-Berliner Bezirk Wedding in die Verlängerung der Bernauer Straße auf Ost-Berliner Seite, die Eberswalder Straße im Bezirk Prenzlauer Berg. Mauer und Grenzstreifen laufen, von Norden (links im Bild) kommend, entlang der Schwedter Straße. Im Todesstreifen wurde spanische Reiter (Panzersperren) platziert.

The border strip on Eberswalder Straße and Bernauer Straße, 1980

Looking across from the West Berlin district of Wedding to the extension of Bernauer Straße, named Eberswalder Straße in the eastern district of Prenzlauer Berg. The Wall and border strip run from the north (on the left) along Schwedter Straße. In the death strip, antitank barriers were placed.

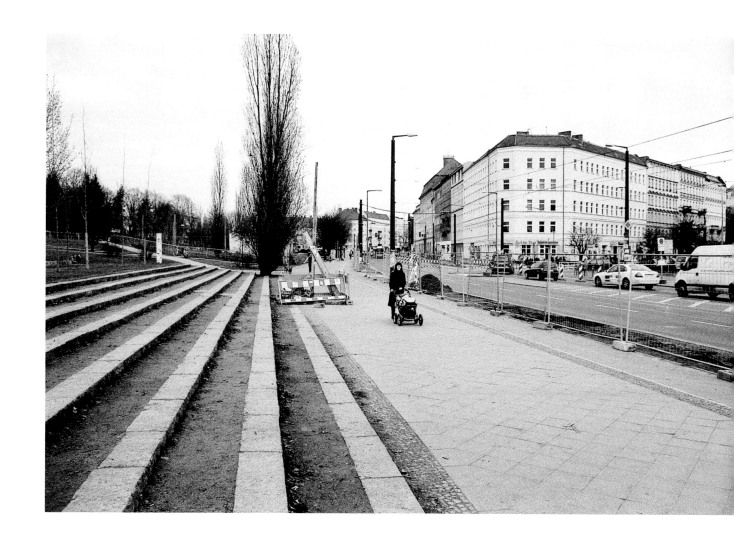

*Eberswalder und Bernauer Straße, 2009*

Die Stufen links im Bild führen zum Mauerpark entlang
der in diesem Abschnitt autofreien Schwedter Straße.
Der östliche Streifen des Mauerparks liegt auf dem
ehemaligen Todesstreifen; er grenzt an den Friedrich-
Ludwig-Jahn-Sportpark (am linken Bildrand).

*Eberswalder Straße and Bernauer Straße, 2009*

The steps on the left lead to the Wall Park along
Schwedter Straße which is car-free here. The eastern
strip of the Wall Park is located on the former death
strip; it borders on the Friedrich-Ludwig-Jahn-Sport-
park (left edge).

123

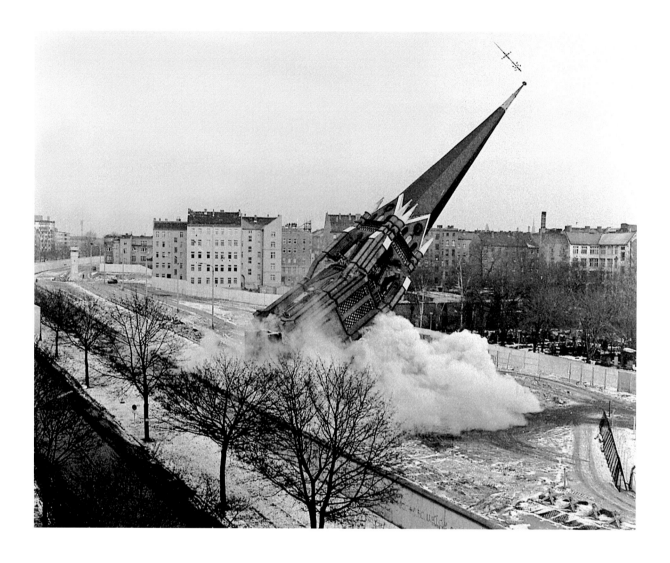

*Die Sprengung der Versöhnungskirche, 1985*

Beiderseits der Versöhnungskirche standen Wachtürme, zwischen denen der Sichtkontakt durch die Kirche verhindert wurde. Die Ost-Berliner Behörden beschlossen daher deren Beseitigung. Ende Januar 1985 wurde das Gotteshaus in zwei Etappen gesprengt.

*Blasting of the Church of Reconciliation, 1985*

There were watchtowers on either side of the church, that impeded the intervisibility. The authorities in East Berlin decided to raze it to the ground by blasting it in two stages at the end of January 1985.

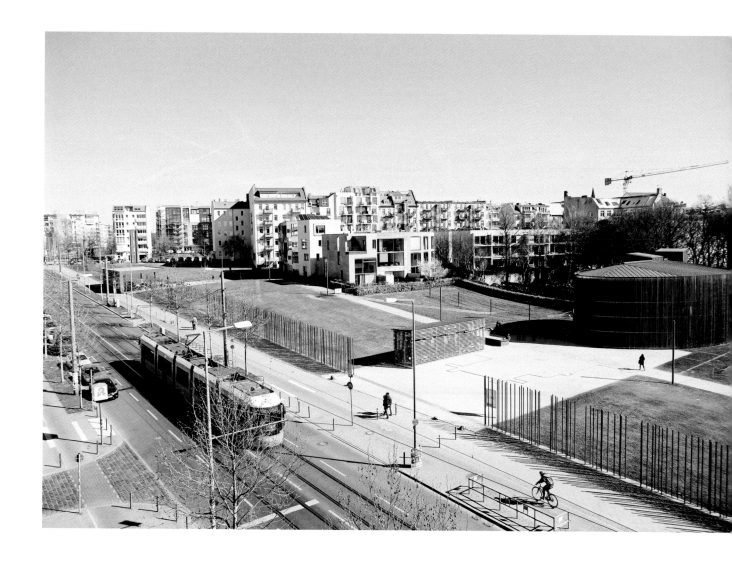

*Die Südseite der Bernauer Straße, 2014*

Einst erfüllt mit pulsierendem Leben, wurde das Gebiet
an der südlichen Straßenseite durch den Abriss der
Bebauung zu einem Teil des Mauerstreifens, mit dem
Mauerfall zu einer riesigen Brache. Die 2000 eingeweih-
te »Kapelle der Versöhnung« (rechts) verdeutlicht die
Unmöglichkeit bloßer »Stadtreparatur«.

*Bernauer Straße, south side, 2014*

Once buzzing with urban life, the area on the southern
side of the street was cleared of buildings and was
integrated into the border strip. After the Wall had
come down, a huge wasteland remained. The "Chapel
of Reconciliation" (right), consecrated in 2000, clearly
shows that a mere "urban repair" is impossible.

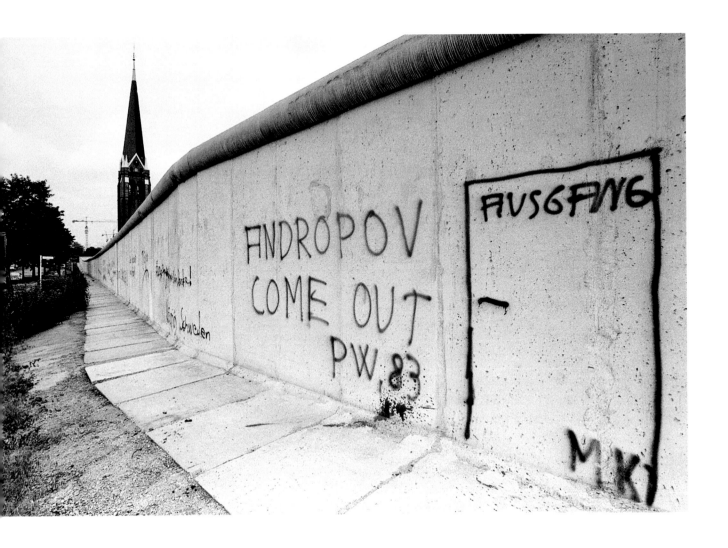

*Blick die Bernauer Straße hinauf, 1983*

*Looking up Bernauer Straße, 1983*

Die Bernauer Straße gehörte zum West-Berliner Bezirk Wedding, die Häuser an der Südseite hingegen zum Ost-Berliner Bezirk Mitte. Das ermöglichte nach dem 13. August 1961 spektakuläre Fluchten aus diesen Häusern, bis sie bis Ende Oktober 1961 geräumt und die Türen und Fenster zur Straße zugemauert wurden. 1965 wurden die Häuser abgerissen. Im Hintergrund der Turm der Versöhnungskirche, 1985 gesprengt. Juri Andropow war von November 1982 bis zu seinem Tod im Februar 1984 Generalsekretär des Zentralkomitees der KPdSU.

Bernauer Straße belonged to the West Berlin district of Wedding, the houses on the south side to the East Berlin district of Mitte. After 13 August 1961, this allowed for spectacular escapes from these houses until they were cleared by the end of October 1961 and the doors and windows to the street were bricked up. In 1965, the houses were torn down. In the background the spire of the Church of Reconciliation, blasted in 1985. Yuri Andropov was from November 1982 until his death in February 1984 Secretary General of the Central Committee of the CPSU.

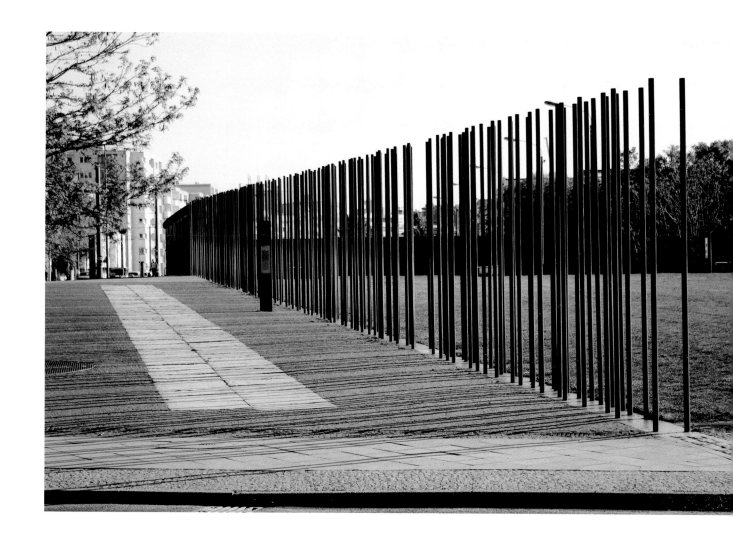

*Blick von der Ecke Gartenstraße die Bernauer Straße hinauf, 2014*

In der offiziellen Gedenkstätte Berliner Mauer stehen noch einige Stücke der Mauer, deren Verlauf durch rostige Stahlstangen ergänzt wurde. Zwischen zwei senkrecht zur Mauer und zur Straße stehenden Stahlwänden (Bildhintergrund) wurde ein kurzes Stück der Grenzanlagen rekonstruiert, mitsamt Wachturm.

*Looking up Bernauer Straße from the corner of Gartenstraße, 2014*

In the official Berlin Wall Memorial there are still some sections of the Wall standing, complemented by rusty steel rods. Between two steel walls (background) perpendicular to the Wall and the street, a short section of the border installations has been reconstructed, including a watchtower.

127

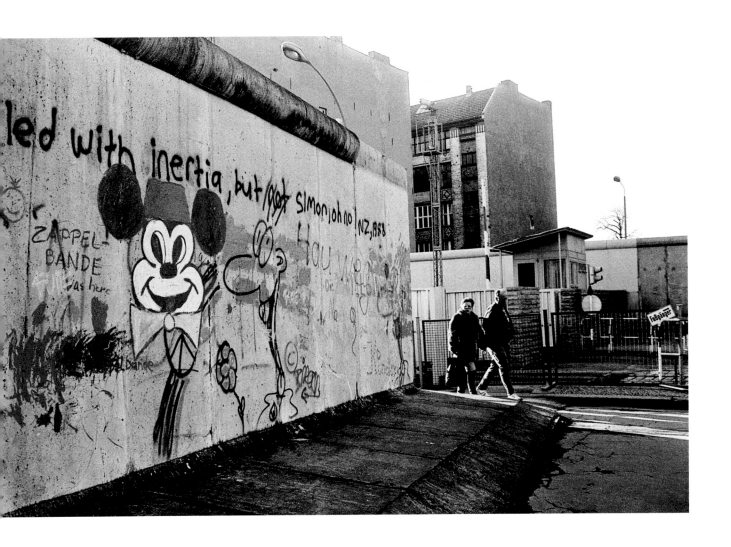

Der Grenzübergang Chaussee- Ecke Liesenstraße,
Januar 1990

Die Mauer beschrieb am Ende der Bernauer Straße
einen rechten Winkel nach Nordwesten, knickte an der
Liesenstraße nach Südwesten ab und führte westlich
über die Chausseestraße. Die Grenzübergangsstelle
Chausseestraße für West-Berliner wurde am 9. No-
vember 1989 um 20.34 Uhr für alle geöffnet, und Micky
Maus war schon vorher da.

The border crossing on Chausseestraße corner of
Liesenstraße, January 1990

At the end of Bernauer Straße the Wall sheered off to
the north-west at a right angle, turned south-west at
Liesenstraße and went west across Chausseestraße.
The Chausseestraße border crossing for West Berliners
opened up completely at 8.34 p.m. on 9 November
1989, and Mickey Mouse was already there.

*Die Chausseestraße an der Liesenstraße, 2014*

*Chausseestraße at the corner of Liesenstraße, 2014*

An der Chausseestraße vor dem Oranienburger Tor lagen im 19. Jahrhundert die großen Berliner Maschinenfabriken. Dort wo die Mauer entlang der Liesenstraße verlief und sich zur Grenzübergangsstelle Chausseestraße öffnete, steht nun eine Tankstelle, und drum herum wird heftig gebaut.

In the 19th century the big engineering factories were located on Chausseestraße in front of the Oranienburg Gate. Where the wall ran along Liesenstraße leaving a gap for the Chausseestraße border crossing point, there is now a filling station with a lot of construction work around it.

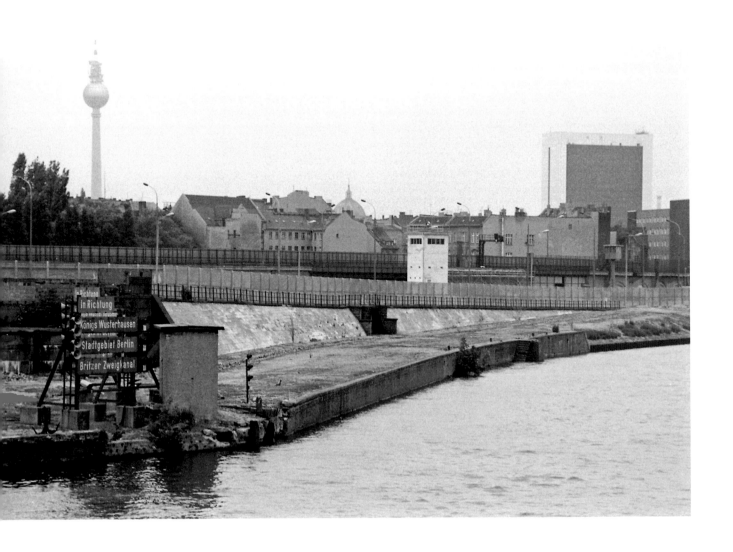

*Kapelle-Ufer an der Spree und Stadtbahn-Viadukt, 1986*
Die kriegszerstörte Brücke über die Einfahrt zum Humboldthafen (links) wurde abgeräumt, auf der Straße Kapelle-Ufer (Mitte) steht ein Grenzzaun, im breiten Wachturm ist eine Führungsstelle der DDR-Grenztruppen. Der Stadtbahn-Viadukt dahinter war beidseitig eingezäunt, damit niemand zu Fuß über die Gleise oder nach Aufspringen auf einen fahrenden Zug unkontrolliert nach West-Berlin gelangen sollte hinter dem Grenzbahnhof Friedrichstraße (links am Fuß des Hochhauses des Internationalen Handelszentrums, rechts). Auf der Spree fahren hier weder West- noch Ost-Fahrgastschiffe, weil dieser Flussabschnitt in Ost-Berlin westseits der Grenzsperren liegt.

*Kapelle-Ufer along the river Spree, and the railway viaduct, 1986*
The war destroyed bridge over the entrance to Humboldt Harbour (left) has been removed, on the street Kapelle-Ufer (centre) is a border fence, in the broad watchtower is a command post of the GDR border troops. The railway viaduct behind it was fenced on both sides, so that no one should walk along the tracks or jump onto a moving train to get unchecked to West Berlin after the border station Friedrichstraße (at the left foot of the tower of the International Trade Centre, right). On the Spree there are neither Western nor Eastern passenger ships, because this section of the river is in East Berlin, west of the border barriers.

Kapelle-Ufer mit Neubauten, 2014
Die Straße Kapelle-Ufer ist wieder benutzbar, links
führt die neue Hugo-Preuß-Brücke wieder über die Ein-
fahrt zum Humboldthafen, und auf der Spree fahren
auch hier wieder Ausflugsschiffe. Auf dem ehemaligen
Grenzstreifen stehen nun Bürohäuser: Ganz rechts
das Haus der Bundespressekonferenz; links und mittig
seit kurzem das Bundesministerium für Bildung und
Forschung. Das Grundstück wurde zuvor einige Jahre
lang als »BundesPresseStrand« mit Gastronomie und
Veranstaltungen zwischengenutzt.

Kapelle-Ufer with new buildings, 2014
The street Kapelle-Ufer is usable again, on the left, the
new bridge Hugo-Preuß-Brücke crosses the entrance
to Humboldt Harbour again, and on the river Spree
there are again excursion boats here, too. On the
former border strip are now office buildings: Far right,
the house of the Federal Press Conference; left and
centre, recently, the Federal Ministry of Education and
Research. The site has previously been used temporarily
for some years as "Federal Press Beach" with catering
and events.

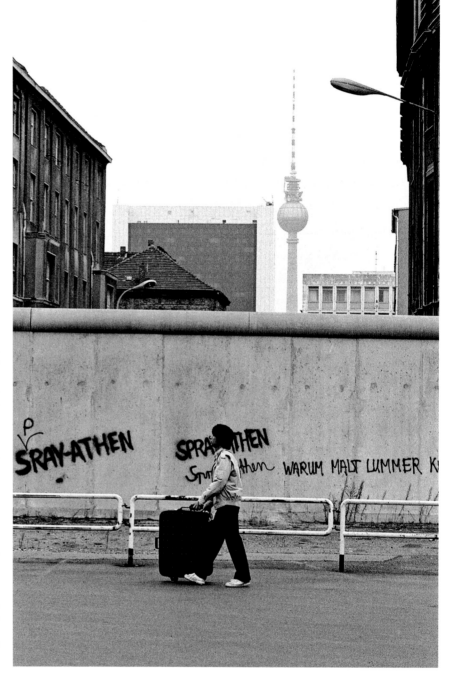

*Blick von der Scheidemannstraße über die Mauer, 1982*

*Jenseits der Mauer führte hier die Clara-Zetkin-Straße durch die Dorotheenstadt, die seit 1674 entstandene zweite Berliner Neustadt, und ins nahe gelegene Universitätsviertel. Seit 1995 heißt die Straße wieder Dorotheenstraße.*

*View over the Wall from Scheidemannstraße, 1982*

*On the other side of the Wall, Clara-Zetkin-Straße ran through Dorotheenstadt, Berlin's second new quarter built from 1674 on, and into the nearby university quarter. Since 1995 the street is named Dorotheenstraße again.*

*Blick in die Dorotheenstraße Richtung Osten, 2002*

*Die »neue« Dorotheenstraße, fast ausschließlich von neu errichteten Bürohäusern für die Bundestagsabgeordneten gesäumt, ist als nördliche Umfahrung des Brandenburger Tores zur wichtigen Verbindung zwischen Reichstagsgebäude und der Straße Unter den Linden geworden.*

*View along Dorotheenstraße towards the east, 2002*

*The "new" Dorotheenstraße, almost exclusively lined by new office buildings for Members of the Bundestag, has become an important traffic connection between the Reichstag and the street Unter den Linden, bypassing the Brandenburg Gate to the north.*

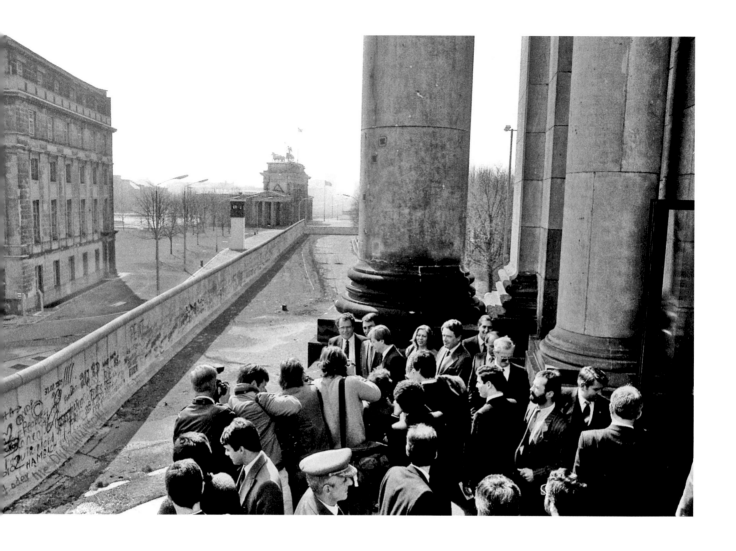

*Blick vom Ostbalkon des Reichstags auf Mauer und Brandenburger Tor, 1986*

Beim Besuch von Staatsgästen im Westteil der Stadt gehörte es zum Ritual, vom Ostbalkon des Reichstags aus einen Blick über die Mauer zu werfen. Das Foto zeigt den Regierenden Bürgermeister Eberhard Diepgen mit dem portugiesischen Ministerpräsidenten Anibal Cavaco Silva im April 1986.

*View of the Wall and Brandenburg Gate from the east balcony of the Reichstag, 1986*

In West Berlin it was a standard ritual to take state visitors to the east balcony of the Reichstag and look over the Wall. This picture shows the governing mayor, Eberhard Diepgen, with the Portuguese prime minister, Anibal Cavaco Silva, in April 1986.

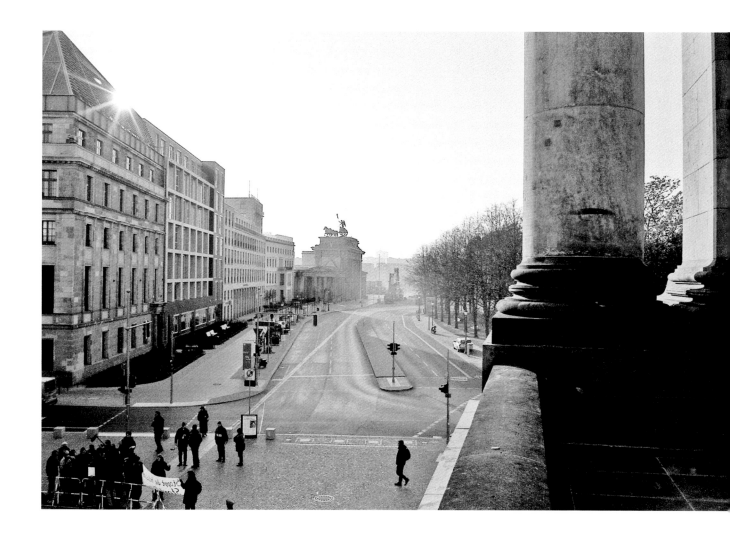

*Blick vom Reichstag zum Brandenburger Tor, 2002*

Das links sichtbare Gebäude, das ehemalige Ingenieursvereinshaus, ist kein Solitär mehr. Es wurde in die neu entstandene, aber zur Berliner Bautradition gehörende Blockrandbebauung mit Büro- und Geschäftshausbauten – deren Rasterfassaden allerdings oft recht monoton wirken – einbezogen.

*View of the Brandenburg Gate from the Reichstag, 2002*

On the left the former Engineers Association building no longer stands isolated. It has been included into the new perimeter block development, a traditional building design for shops and offices in Berlin, but their modular facades are often rather monotonous.

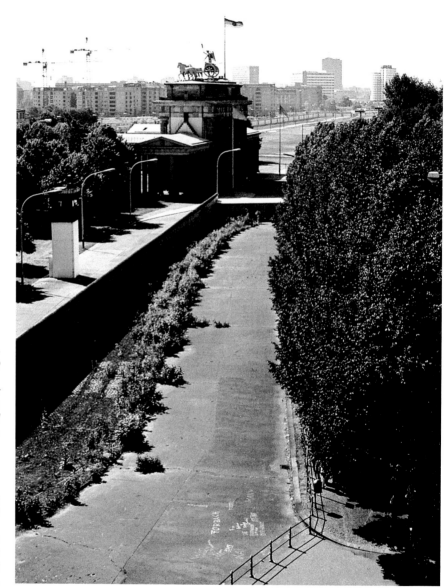

*Die Mauer nördlich des Branden-
burger Tors, Juni 1989*

*Wie hier verlief die DDR-Mauer
in Berlin-Mitte streckenweise an
gleicher Stelle wie die Zoll- und
Akzisemauer des 18. Jahrhunderts.*

*The Wall to the north of the
Brandenburg Gate, June 1989*

*As here, the GDR Wall stood in
Berlin-Mitte in some sections in
the same place as the 18th century
customs and excise wall.*

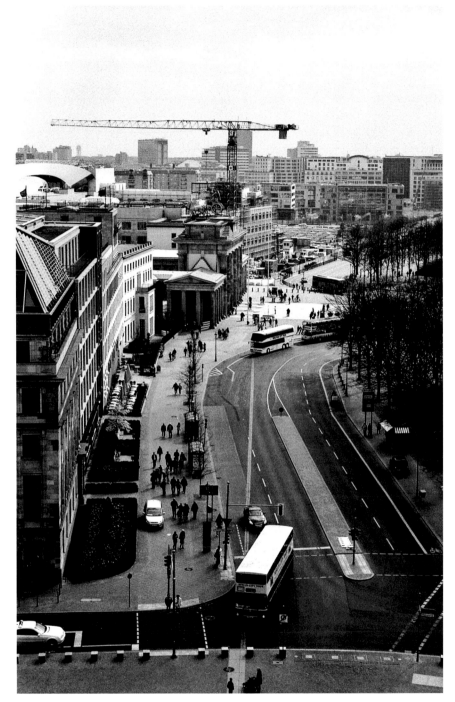

*Blick vom Dach des Reichstags-
gebäudes Richtung Brandenburger
Tor, 2007*

**Aus dem Grenzstreifen nördlich des
Brandenburger Tores wurde wieder
eine Straße mit »geschlossener
Blockrandbebauung«.**

*View from the roof of the Reichstag
towards the Brandenburg Gate,
2007*

**The border strip has again become
a street lined with "closed perimeter
block development".**

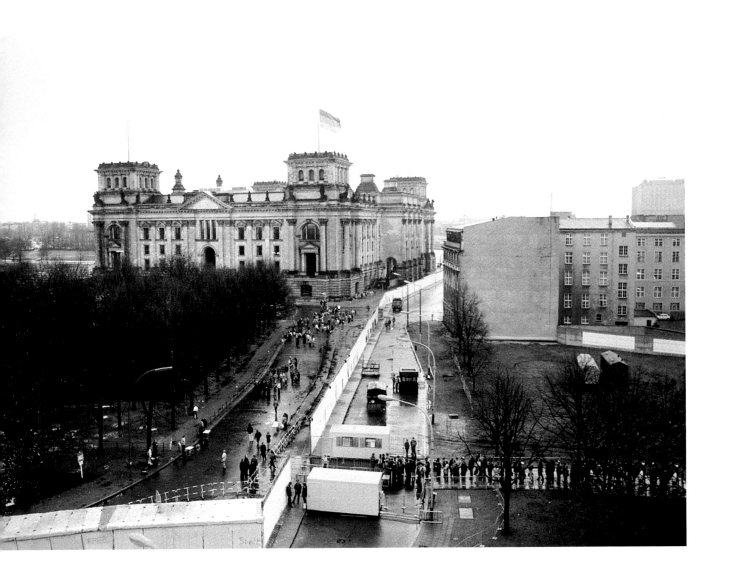

Die Mauer zwischen Reichstag und Brandenburger Tor, Januar 1990

*The Wall between the Reichstag and Brandenburg Gate, January 1990*

Entlang der Sommerstraße (heute: Ebertstraße), die östlich am 1894 eingeweihten Reichstag vorbeiführte, verlief bis 1867 die Zoll- und Akzisemauer. Es war ein demonstrativer Akt, den Reichstag hierher zu »verbannen«. Mit dem Bau der Mauer von 1961 geriet das Gebäude erneut ins Abseits.

*Until 1867 the customs and excise wall followed Sommerstraße (now Ebertstraße) which ran east beside the Reichstag, the Imperial Parliament (inaugurated in 1894). The parliament was "banned" from the city in an act of defiance. The Wall of 1961 cut the building off yet again.*

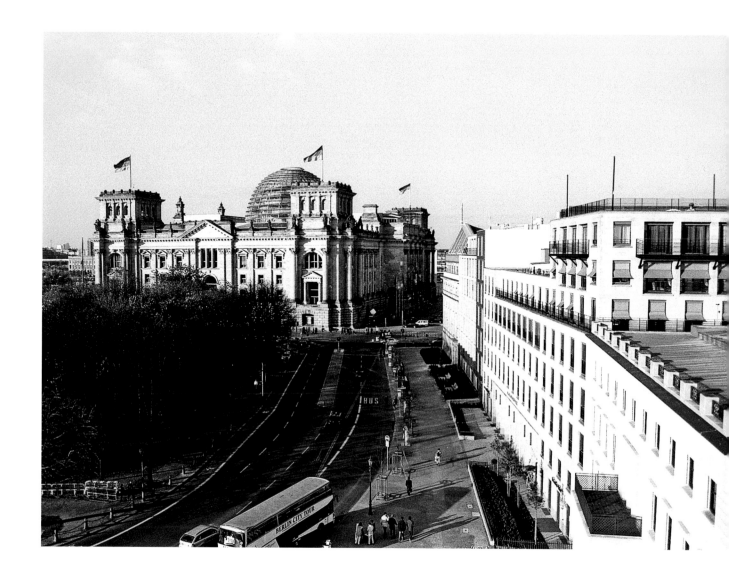

*Blick auf den Reichstag vom Brandenburger Tor, 2002*

Plenartagungen des Bundestages im rekonstruierten
Reichstagsgebäude sind zur Selbstverständlichkeit, vor
allem aber ist die begehbare gläserne Kuppel (Architekt
Sir Norman Foster) zu einem der größten Anziehungs-
punkte des »neuen« Berlin geworden.

*View of the Reichstag from the Brandenburg Gate, 2002*

Plenary parliamentary sessions of the Bundestag in
the reconstructed Reichstag building have become a
matter of course, and the walkable glass dome (archi-
tect Sir Norman Foster) has become one of the biggest
tourist attractions of the "new" Berlin.

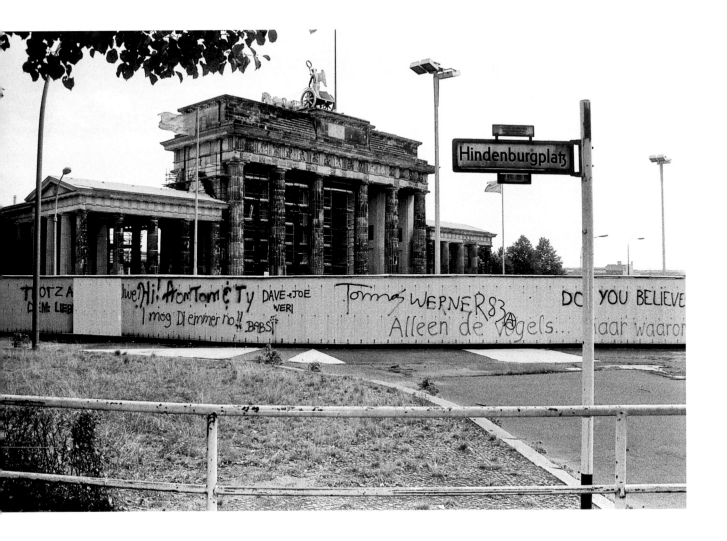

*Das Brandenburger Tor von Nordwesten, 1986*

*The Brandenburg Gate from the north-west, 1986*

*Mehr als ein halbes Jahrhundert nach der Ernennung des »Führers« der NSDAP, Adolf Hitler, zum Reichskanzler durch Reichspräsident Hindenburg wird der 1934 bei dessen Tod umbenannte Platz vor dem Brandenburger Tor auf westlicher Seite noch immer offiziell als »Hindenburgplatz« bezeichnet.*

*When the German President, Hindenburg, died in 1934, the square in front of the Brandenburg Gate received his name, still officially used on the Western side over fifty years after Hindenburg appointed the Nazi leader, Adolf Hitler, Chancellor of Germany.*

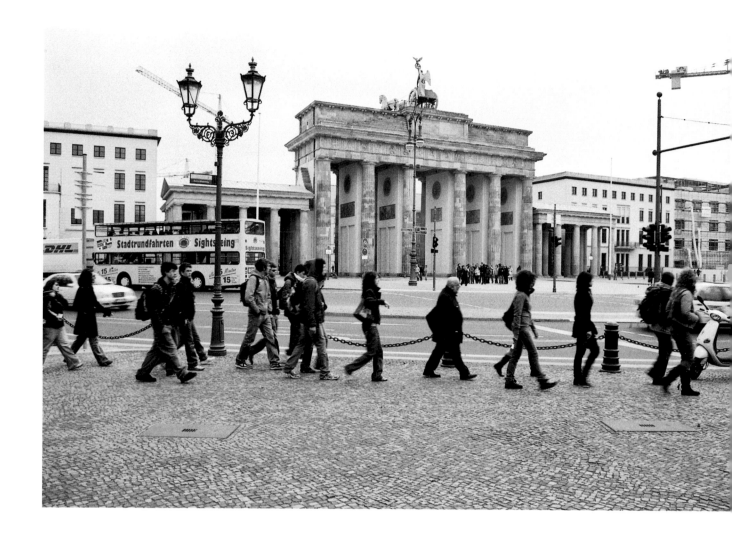

*Das Brandenburger Tor von Nordwesten, 2007*

*Das Tor hat ein bisschen viel Geschichte erlebt: Eroberung und Besetzung, die Entführung der Quadriga als Kriegsbeute, heimkehrende Soldaten, Militärparaden und Festempfänge, Bürgerkriegskämpfe, den Fackelmarsch der SA, den »Kampf um Berlin«, den Mauerbau. Inmitten des »neuen Berlin« wirkt es ein wenig verloren.*

*The Brandenburg Gate from the north-west, 2007*

*This gate has seen much history: defeat and occupation, the quadriga taken as war booty, returning soldiers, military parades and celebrations, civil war, the torchlight parade of Hitler's SA, the "Battle of Berlin", the Wall. It looks a bit lost in the heart of "new Berlin".*

141

*Das Brandenburger Tor vom Pariser Platz aus gesehen, 1983*

Der leere Pariser Platz und das Brandenburger Tor waren zu DDR-Zeiten nur Grenztruppen und Staatsgästen oder mit Sondergenehmigung zugänglich. Der Quadriga auf dem Tor fehlten seit 1958 der Preußenadler auf dem Lorbeerkranz und das Eiserne Kreuz darin.

*The Brandenburg Gate seen from Pariser Platz, 1983*

The empty Pariser Platz and the Brandenburg Gate were accessible during GDR times only to border troops and state guests or with special permission. Since 1958 the quadriga on the gate was lacking the Prussian eagle on top of the laurel wreath, and the Iron Cross inside that.

*Das Brandenburger Tor vom Pariser Platz aus,*
*Weihnachten 1989*

*The Brandenburg Gate seen from Pariser Platz,*
*Christmas 1989*

*Bis zur Grenzöffnung am 22. Dezember 1989 für nor-*
*malsterbliche Passanten unzugänglich, ist der Pariser*
*Platz, ehemals Berlins »Empfangssalon«, nunmehr*
*zum Veranstaltungsort und zur Touristenattraktion*
*geworden. Seine neu zu entwerfende Randbebauung*
*war Gegenstand heftiger Kontroversen.*

*Pariser Platz was closed to "normal" people until 22*
*December 1989. The square was once Berlin's "recep-*
*tion room". Now it is the scene of various events and a*
*tourist attraction. The new development around it has*
*been the subject of intense controversy.*

143

Bibliografische Information der Deutschen Nationalbibliothek: Die Deutsche Nationalbibliothek verzeichnet diese Publikation in der Deutschen Nationalbibliografie; detaillierte bibliografische Daten sind im Internet über http://dnb.dnb.de abrufbar.

Bibliographic information published by the Deutsche Nationalbibliothek: The Deutsche Nationalbibliothek lists this publication in the Deutsche Nationalbibliografie; detailed bibliographic data are available on the Internet at http://dnb.dnb.de .

1. Auflage/1st Edition 2014
© 2014 Stadtwandel Verlag, Leibnizstr. 13, D-93055 Regensburg
ISBN 978-3-86711-227-7

Umschlaggestaltung/Cover design: Anna Braungart, Tübingen
Satz/Layout: typegerecht, Berlin
Druck/Print: AZ Druck und Datentechnik GmbH
Übersetzung/Translation: Mario Martin

Weitere Informationen zum Verlagsprogramm erhalten Sie unter: www.stadtwandel.de

Further information about our publications can be found under: www.stadtwandel.de